Real-World Feminist Handbook

Real-World Feminist Handbook

Practical Advice on How to Find, Win & Kick Ass at Your First Job

Michelle Kinsman

You CAN & You WILL.
♥
Michelle Kinsman

ISBN: 978-1-7324476-0-8 (paperback)
978-1-7324476-1-5 (eBook)

Cover and book design by Caroline Teagle Johnson

realworldfeminist.com

For orders or inquiries, please use the form on the website.

For Jackie and Jessie,
who one fateful night in New York City said,
"Aunt Michelle, you should write a book."

Acknowledgments

No Real-World Feminist does it alone. I've been blessed to have a few people in my corner.

Thank you, Azul Terronez. Your coaching and process helped me turn the ideas screaming to get out of my head for years into this book.

Thank you, Ann Maynard. Your practical advice helped me find and fine-tune my voice.

Thank you, Jonathan and Stephanie Fields. The inspiration and connections provided at Camp GLP helped me turn my dream of writing a book into a reality.

Thank you to my soul-sister, Collie Turner. Your fierce cheerleading and fiercer loyalty have helped me dream bigger with each passing year.

Thank you to my mom and dad. The love and guidance you endlessly give have always made it easy for me to believe anything is possible.

Thank you to my husband, Tim. You never waver in your encouragement and support. It takes a badass to love a badass like me. I love you forever, my Zatz.

Table of Contents

. . .

You have been a force to be reckoned with since the day you were born.

No one needs to tell you that. You know it. You feel it.

You were not put on this Earth to be mediocre. To phone it in. To settle for what could have been.

That kind of bullshit is not for you.

You feel it inside.

That flame.

That power waiting to be fully unleashed.

Some days, you feel it banging on your chest demanding to come out.

Some days, it keeps you warm as you hustle and dream of bigger dreams.

But then, there are other days.

Days where it unsteadies you and coaxes you into the comfort of pizza delivery and just one more episode on Netflix.

Days where it beats you up from the inside out because you have no freaking clue how to unleash that power and get on with the life you imagined.

You are already a powerhouse.

You began as a fearless girl, spinning cartwheels in the grass, making up stories about imagined, faraway places, and playing to win because second place never felt good enough.

You became a pretty darn near perfect teenager. You made the most of your high school experience. Not because you had to. Not because you felt pressured to. You did it because that's the way you are. You give everything your all.

And college…

You know you killed it. You felt lit on fire by the whole experience. Not just the academics. It was the whole package. Your roommates. Your adventures. Your internships. Your opportunities to connect with people from different places, cultures, and life perspectives. You were exposed to the world outside of your hometown, and you are dying to see, feel, and touch as much of it as you can.

Graduation day came and went. Now here you are, trying to figure out how to flip the switch from learning and planning for a successful career into actually starting one.

You feel like your very own version of feminist.

You give mad props to the women who came before you to further the cause, but you don't want to be put in the box of what the world says a feminist looks and acts like.

You know you can light up the world in a way no one else can. On your own terms. With your own rules. No one is going to tell you what a feminist is or isn't.

You are ready to start showing your family, friends—EVERYONE—what you are capable of. More importantly,

you are ready to prove it to yourself.

But, sometimes, you have serious doubts about the real world that you've been itching to conquer. I mean, shiiiiiiiiiit. Any woman with access to a news feed can feel this way at times.

Are we really still fighting for equal pay for equal work?

Are we really hearing real life stories about Hollywood moguls looking the other way and allowing gross instances of sexual misconduct and abuse?

Are we really considering ourselves an advanced society when cases of workplace sexual harassment happen daily and a good ol' boys culture is alive and well in too many places to count?

All of the strong women who influenced us as we grew up helped us believe that we could do anything.

But here we are on an uneven playing field.

Playing by their rules.

Here's good news: you can win the game anyway.

You can learn the unwritten rules and play them to your advantage.

You can hack the system once you understand the system.

And once you're in, you can be one of the disrupters to the system. Break the system. Create a new system that works to the benefit of everyone—an even playing field.

This is where I come in.

I'm the Real-World Feminist, and I'm here to help you hack the system.

Why do I call myself the Real-World Feminist? I also bristle at the bullshit labels that come with the term "feminist."

Because we're not man-hating, humorless PC-robots, and I'm not going to be boxed in by anyone else's idea of what a feminist is.

I consider myself a *career-driven, can't stop won't stop until I'm at the top of my industry* feminist. An *it's not lost on me that my white, middle-class background has brought me advantages that others don't have* kind of feminist. A *not afraid to speak up for what's right and drop a few f-bombs if I need to* feminist. A *marrying my husband was one of the best decisions I've made in my life* feminist. A *take pride in mentoring other women to be kick-ass leaders* feminist. A *90s hip-hop and hair-metal-loving* feminist, who is also a *sing all of the lyrics that others may find offensive* feminist.

That's what I mean by calling myself a Real-World Feminist. Real-World Feminist will look totally different on you. However it looks on you, I know it looks great. Because it's the real you.

I, too, have been dreaming about taking the world by storm since I was a kid. And I, too, had no idea how to take all of that fire and unleash it on the real world.

It took tenacity and many years of learning lessons the hard way, but now here I am. I'm one of the key executives running a large-scale advertising company in one of the big-three global holding companies. When there are tough operational problems no one else can solve, the call for help comes to me. I've defined standards for ad agency project management that competitors have modeled at their own companies. I've taken great pride in helping hundreds of other people build their

careers and leadership prowess.

But I started at the bottom. In fact, I was lower than the bottom. I was in the mud, the pit, the go-nowhere do-nothing intersection of joblessness and cluelessness—and I was stuck there.

Tires spinning in the mud stuck. *Can't get out with a tow truck* stuck. *Completely, infuriatingly, cry-myself-to-sleep-because-I'm-a-total-loser* stuck.

I was fresh out of college, having just spent four years tirelessly pursuing a film degree, and I was ready to leave my mark. But while film school had taught me the art of cinematic storytelling, it gave me nothing in the way of practical advice. I had ambition. I had the smarts. But I had no idea what to do next.

So I found myself back in my childhood bedroom at my parents' home in Middle of Nowhere, Pennsylvania.

I had no job. No health insurance. Most of my friends were long gone, successfully chasing their dreams in other parts of the country. Student loan bills threatened to show up in my mailbox any day.

I was at a loss for how to fix my situation. *Do I move to New York City? How will I afford it? Should I live in Pittsburgh with a few of my old film partners trying to work through the same issues? Do I go back to school? Do I stay put and save money at some menial hourly job?*

Every question produced a series of follow-up challenges. I reasoned, "If I can just look at it the right way, then I'll find the perfect solution." I needed to keep searching, and the answer

would come.

If you are reading this book, you are likely feeling the same way: stuck. You're out of school—*now what?* You're debating your job options—*now what?* You're overloaded with choices and possibilities—*now what?* You hate your hometown—*now what?* You have bills piling up—*now what?*

Well, now it's time to get unstuck.

And unlike me, you don't need to figure it out on your own. I'm here to help, because we Real-World Feminists need to stick together. I'm here to encourage you to not sell out your dreams of a brilliant career. I'm here to help you understand how typical corporate America works so you can use this information to your advantage and land the job. And I'm here to give you practical advice on how you can stand out as a star performer once you get the job.

We don't have any time to waste.

We need to get your generation of Real-World Feminists further, faster.

My advice can save you years of learning how to navigate the system on your own.

We need to get as many Real-World Feminists into corporate America as we can, so that we can get on with building that new system we all know is possible.

Hack Your Brain:

How to Turn Your Big Dreams into Big Action

. . .

You are about to embark on an exciting journey.

It's what you've been itching for these long years.

It's *your* time! Your time to unleash your inner badass and start building the professional career of your dreams.

You'll catch some lucky breaks along the way, and things will fall into place better than you imagined or planned.

But often, you'll hit obstacles and setbacks and wonder *what's wrong with me? Why can't I figure this out?* Adversity is a guarantee.

Life is not a formulaic Hallmark or Lifetime movie. It's a journey, a challenge.

Your challenge.

Your puzzle to solve.

Your purpose.

There *will* be people you meet who make everything look effortless. They'll get started in their careers before you, and you'll wonder if you'll ever earn a salary in their range. So what?

There *will* be those who disappoint you. So what?

You *will* make mistakes. Some of them will be whoppers.

So what?

There *will* be times you feel inadequate and confused and want to quit. So what?

It's all part of the territory. You can't appreciate how sweet success will feel until you have some failures. Don't let Instagram fool you; life won't be one big, perfect happy-fest.

Now with many years of professional experience under my belt, I often take part in mentorship events or have chats when I connect with a young woman hoping for advice. There is a common question they ask.

When you look back, is there one thing you wish you did differently?

They want me to unlock a secret, a how-do-you-get-ahead glimpse behind the curtain. And I always take a deep breath and offer the same answer.

I wish I enjoyed it all more.

I've been Type-A since birth, such a critical perfectionist that I can't go easy on myself.

Every challenge was an insult. "*Why does this always happen to me?*" A chance to shake my fist at the heavens.

Every bump struck me like an over-the-top obstacle. "*Why am I always behind?*" A chance to beat myself up for not being able to tackle it the instant the challenge surfaced.

Every disappointment magnified into failure. "*What is wrong with me?*" A chance to revel and soak in my insecurities.

Far too often, I marinated in negative thoughts and emotions. Now I understand that trapping myself in these feelings was counter-productive. Negative energy only feeds adverse outcomes, and I have many years' worth of evidence

to prove the point.

You don't have the time or energy to waste on these kinds of negative feelings! We need you to get on with getting after it, my Real-World Feminist.

My advice to you is to consider every experience as research. Some experiments will fail, but some will be soaring successes! Your setbacks contain valuable lessons the universe wants you to learn. Take the time to examine them and make adjustments to your path forward.

You will be just as successful as you imagine you can be. Set that bar high and move forward. Be compassionate to yourself when you hit a challenge and give yourself some grace to figure it out.

Get ready to enjoy the ride, bumps and all.

Now take a deep breath.

Believe you will do it.

You have a meaningful contribution to make in this world.

We all have unique talents and interests. We all have different strengths and passions. We all can make meaningful contributions in this world. Ponder that for a moment—what a wonderful concept!

It sounds great on paper, at least.

But, what if you have no idea what you'd like your meaningful contribution to be?

I mean, how can you get to the kicking ass part if you don't even know what you want to achieve?! This confusion and doubt can be intimidating—downright paralyzing—at the start of your career.

Before we can talk about hacking your job search and corporate America, we need to hack something else.

It's going to feel personal.

We need to stop the constant swirl of questions about your future, the review of endless options, the self-doubt. At the very least, we need to slow it all down. Taking the time to narrow your focus will help you move from thinking about starting your career to actually doing it.

We need to hack your brain.

Hack #1:

Sync Your Brain Up with Your Heart

You've spent your life to this point fantasizing about the person you would be when you grow up.

I dreamed of many careers.

First, I wanted to be a doctor. It was as ambitious of a dream as I could imagine at age four.

Next, I decided I would become an astronomer. I was obsessed with telescopes and Sunday night episodes of *Cosmos* on PBS.

I would be a detective, just like Nancy Drew.

I would be a lawyer. Better yet, I envisioned myself as the next-generation Judge Wapner, my generation's Judge Judy.

I would be a writer. This one, as you may have guessed, never quite disappeared from my mind.

I would be an award-winning filmmaker, telling stories of individualist feminist heroines. Movies that showed women triumphantly overcoming the odds and made it clear that a woman didn't need to adhere to the traditional path of marriage and kids to find fulfillment.

(I still might follow through on that one.)

The point is, I always dreamed big. I refused to fit in the box of anyone else's expectations. I wanted to achieve meaningful things. Make an impact.

So do you.

We have big dreams that stick with us from grade school to graduation day.

But then that day comes.

The day when you get punched in the face by reality.

The day when you realize childhood is officially over; it's time to actually *become* something, someone.

Do you remember the day this happened to you?

I remember the day it happened to me quite clearly. It didn't arrive when I graduated from Penn State University the way it did for so many of my classmates. The lease to my college apartment wasn't up until August, which meant I had three months of delicious, suspended reality. No job and no commitments. Three months of connecting with friends, hanging out in coffee shops, playing cards in our favorite pub, and day-dreaming about the people we might become. It was glorious.

Moving day came early, though. Apparently, I had a copy of the previous year's lease when I planned my departure date. I realized my mistake when the landlord's maintenance crew pounded on my front door a week earlier than expected. Talk about a wake-up call! I had twenty-four hours to pack everything up and haul out of town.

I had no time to prepare, no time to think—just one day to box up all of my belongings, clean and spackle the joint to

preserve our security deposit, and get out the eff out. My dad arrived that evening, we loaded up his station wagon, and off we went.

Reality struck the following morning as I unpacked my clothes into the drawers of the dresser I'd had since I was eleven. I had woken up in my childhood bedroom in my parents' house and heaved a sigh. I had no job, no job prospects, a savings account depleted by a summer of bar tabs, student loans arriving in my mailbox soon, and no clue on how to solve any of these problems.

Reality did more than hit me that day. It bitch-slapped me.

This day strikes each of us at different times: graduation, handing in your last final, or the first class of your senior year. Perhaps it comes during orientation at the job you didn't want but took because you needed a paycheck.

It blasts you with a tidal wave of emotions. Excited, optimistic, anxious, confused, overwhelmed feelings crash down on you all at once.

Here you are. Day One of adulting! Day One of "real life"! *OMFG.*

How the hell do I start?

It's okay. Take a deep breath. This response is totally reasonable. We have all reached this point. And we got through it. You will, too.

We are going to start the process by slowing down the feverish swirl in your head. In order to hack your brain, you need to understand what's in your heart.

This means the first step is quite simple.

You need to figure out what you really and truly want.

Before you roll your eyes and flip to the next chapter, I want to challenge you on this simple question.

Do you know what you *really* want out of a career?

Does the mere thought of it light you up?

Or is it what your parents or family expect you to do?

Or is it what you assume the first step in your target industry should be?

Or are you simply comparing yourself to what your friends are doing?

You'll never feel satisfied in your career if you aren't being honest with yourself. Stick with me, Grasshopper. I've got a journaling exercise to help you get to the bottom of it.

The trick is, you can't just think these thoughts in your head; the process only works if you let them out on paper. So grab a notebook. Yes, an actual journal and a pen. Ideas flow better when you write the old-fashioned way—plus, it'll keep you honest. You know how you edit while you type on your phone or computer? Let's prevent that. We need your authentic, unedited thoughts.

Your answers need to come from you.

Oh, and one more thing:

Don't worry about HOW yet. We'll get there; you don't need to worry about it right now.

Let's dig in.

You have a degree, so you must have a general sense of where your interests lie. That Marketing or Environmental Science major wasn't for laughs, right? I want you to imagine what

your life looks like five years from now. You have successfully broken into your field, and you feel happy and satisfied. What do you see? Picture it in 3D and jot down what you see. Every detail. What about the image makes you smile to yourself? What feels good?

Describe your surroundings.

Where are you working? Are you in a traditional office space? Or do you imagine a contemporary open-concept model? Are you at a desk or out in the field? Do you work from home? Are you outdoors? Is your workplace in a remote area, or in one of the greatest cities in the world?

Describe the setting you see in your mind's eye; it holds clues to what would make you content in a real workplace.

For me, the picture of my future working life came straight out of pop culture. I remember being drawn to and struck by episodes of the 1980s drama *thirtysomething*. Man, I wish this would show up on Netflix, but I digress. The show aired when I was in high school, and adulthood was not far away.

Two of the main characters owned an advertising agency in Philadelphia. The space itself was funky, with glass walls, basketball hoops, and quirky details. The partners always looked like they were having fun while they worked through a stressful pitch for a new client or creative presentation that would make or break their business. I wanted to be them.

It's not lost on me that here I sit, a leader at an advertising agency in Philadelphia. The office is funky, with glass doors, a pool table, and quirky details like a chandelier composed

of antique musical instruments and a conference room with ornate chairs that have been dipped in orange latex. The environment is just as fun and stressful as I imagined it would be. The mind's eye is mighty.

Imagine yourself happily kicking ass at your career. Describe every detail of the reality you see. Draw from your favorite shows, movies, or blogs, too. You like them for a reason!

Describe your team.

Who are your co-workers? Do you work with them closely or independently? Are you part of a large team or small group? What sort of people are they? Do you socialize with them, or do you keep your spheres separate? Are you co-located or spread across the globe? How do you connect with them?

As a kid, I binge-watched old re-runs of *The Dick Van Dyke Show*. (Hey, my parents didn't have cable until I was in college, so I had to work with what I had.) Dick's home life was appealing for sure; Mary Tyler Moore was his stunning wife, for God's sake. But my favorite episodes centered on his career as a comedy writer for a TV show. He spent his days with two formidable writing partners, one of whom was the brilliantly brassy character played by Rose Marie.

Yes! That's what I wanted! I wanted to banter and bounce ideas around with other smart people. I wanted to co-create with a team I loved.

And you know what? I was right. My team is fantastic, and they make me glad to walk into work every day. I love partnering with intelligent and diverse people to create outstanding

projects. This vision is another one that matches close to my reality.

Imagine you are having a great day on the job. Describe every detail of the people working by your side.

Define your non-negotiables.

On the flip side, I want you to determine what would make you unhappy and unsatisfied in your career. What would you detest? What environment would make you cringe? What sort of co-worker dynamics or personality types would make you dread coming into work every day?

You may find that your list begins as a stark 180-degree contrast to the perfect vision you've imagined. But go deeper than that. Write for another five minutes after you think you've completed the task. Set a timer and do it.

I dabbled in a traditional corporate environment enough to know I would never, ever be satisfied working in a place like that. I don't want to be a number on a badge. I don't want to sit in a cube. I don't want to work in a complex with a hundred other companies. I don't want to whisper in the hallway or wear polo shirts and khakis on Casual Friday. I don't want to bond over superficial things like the kids' soccer game. No clock-watchers. No keepers of the status quo. I want to drop an F-bomb without the fear of being reported to human resources.

Those are my non-negotiables. What are yours?

Understand why you imagined this specific ideal day.

Here's the last piece of our journaling exercise. It's time to synthesize everything you've written. These details you've been imagining—they point you in the direction of the real question you need to consider:

Why?

Why did you smile to yourself as you described your ideal day?

The moments when you found your pen could barely keep up with your thoughts—why did you feel this way?

Why did you have such a guttural reaction to your non-negotiables?

You're close to a breakthrough, so don't quit on me now.

Write down your thoughts about why you had those feelings. Complete the following sentences honestly, and you'll have the keys to figuring out your next move.

> *I want to work in a place like this because…*
> *I want to work with people like this because…*
> *I can't work somewhere like this because…*

Go deep as you can. Lean into it. Break past the simple prompts. Why do you want these things?

Fill in those blanks and face your truth. Keep going until you find it. You will get trapped in an endless loop of questions in your mind until you capture your honest answer to why you want the dream work day that you imagined.

Set aside the notebook once you've written it. Come back

to it tomorrow. Reread the words, out loud for extra impact. Do they sound truthful to your heart? Do they make up the essence of what you want to do with your life? If not, keep journaling until they do.

Pouring your heart out on paper will help your head process feelings into thoughts.

Sync up your brain with your heart, and you will start connecting the dots between where you are today and that future you imagine.

Hack #2:

Make. Just. One. Decision.

You've always known that you have plenty of options.

If one thing doesn't work out, you always have a backup.

Frankly, you like leaving your options open. It feels good. Freedom and flexibility: what's not to love?

But let's be honest. Sometimes options feel overwhelming.

True confession time: earlier this week, it took me an hour to buy socks online. Basic athletic socks.

I can clock *hours* searching for the perfect black boot. I get sucked into the wormhole of online options. I will leave no image of black boots unturned. Even when I find a pair I love, I will search multiple sites to find the best price. I know it's a ridiculous waste of time, but I do it every single time anyway.

So, imagine how I felt at the start of my career. It was like online shopping times a million.

When I headed off to college, I dreamed of a life of making movies or television shows, so a degree in film and video made perfect sense. Despite the worry lines it caused on my mother's face, and despite gentle advice from guidance counselors to

consider a more sensible choice, I knew what I wanted and hotly pursued it.

I gave it my all. No regrets. It felt pretty badass.

But then I graduated.

And moved back to my parents' house.

And had no idea how to start my career.

And got stuck. *So* stuck.

Questions and concerns ran through my mind at a mile a minute, 24/7:

> *How do I find a job in the film or video field? Do I need to move to New York City to break into the industry? Or maybe Los Angeles? How can I move if I don't have a job? How are other people doing it? How the heck will I leave my parents' house? Maybe I should go back to school? Oh my God, student loan bills are due* when?

Ugh. It was awful. These questions swirled for weeks, months, and, if I am honest with you, about two years. Two years of anxiety, stress, and occasional flat-out depression. My questions overwhelmed me, as though I were a character in a police TV show who has fifteen seconds to dismantle a ticking bomb. *Which wire do you clip first?* I had no idea how to start. Fortunately, there wasn't a building full of civilians counting on me to figure it out.

I couldn't see my way out, but that didn't mean it wasn't there. You have a path out of all the confusion, too.

It all starts with a single decision.

Forget the stream of questions freaking you out. For now, I want you to put all your questions aside and focus on one decision. Just one.

For me, following through on a single decision was the beginning of a whole new chapter in my life. After nearly two years of flailing and agonizing, it boiled down to a resolution I made one summer night.

I am going to move to Philadelphia, I declared.

Not *I think I'm going to move to Philadelphia*. Not *should I move to Philadelphia?*

It was an actual hard and fast decision. I realized I had to do *something*. This move would be that *something*.

Decision made. That was it. Change my scenery. I had to get to an urban area with more professional opportunities. I needed to live somewhere I could connect with old friends and establish new connections. I would chart a new course.

Sure, there was still the question of *how* I would make it happen. But it could wait. Forget "how" for now. Seriously. We'll come back to it later.

For now, your mission is clear. And that is to make one decision.

Take a step back and consider the journaling exercise you completed earlier about how your ideal day five years from now would look. You know the life that would make your heart happy. You identified your non-negotiables. Read over that list and think: *What is the one decision I can make to start forward momentum?*

Let's be clear: you're not looking for a decision to solve

everything. To solve everything will take time and a proper journey. You're looking for one idea, a thought to help you start.

The first step of a journey is the most crucial. It takes...

Courage.

Patience and grit to see it through.

Wisdom to understand that life's transformational challenges won't come with easy answers.

Determination and, at times, brute force.

Faith and belief that no matter what the outcome, you will be okay.

Every journey began with a step.

What single decision would help you start forward momentum?

Do you need a change of scenery? Do you need to find an hourly job with unusual hours so you can free up time for interviews for your "real" career? Do you need to move out of your parents' house or an apartment shared with roommates who party too much? Do you need to meet people in your target industry?

What is the one decision you could make to get you out of your rut and onto the next chapter?

This decision will not solve everything. No single choice will do that. Stop hunting for it. Don't spin your wheels.

Decide on your first step.

Hack #3:

Bulletproof Your Decision

Your decision feels big. Significant. A little scary.

Honestly, you would have tackled it already if it weren't so challenging.

The big decisions in life are rarely easy. They're complex and dynamic, sparking many questions and tempting you to admire the problem forever.

Your decision may result in a smashing win. It also may end in what feels like a big, fat failure. Know this. Either way, it's a success. You moved forward. The only true failure is failing to act.

But don't get me wrong. You are going to do your best to prepare for a successful outcome. Just like I did when I made my big decision to move to Philadelphia.

I was living back in my hometown set in a rural area—no chance of breaking into the video production world there.

I landed on Philadelphia because my best friend and old college roommate lived there. She had regularly offered a place to stay while I figured out how to get on my feet. There was

also a surprising number of opportunities in film production and advertising in the area.

I did not understand how to break into these industries or how to make professional connections. But I put that aside and focused on my one decision to move.

It was time to break it down and figure out how to make my move to the city possible. To turn your decision into action, you must do the same. Break it down into digestible parts.

Let's work through the process together.

What Do You Need to Understand to Take Action?

Pull out your pen and paper again. Think about all the questions and ideas you have to turn your decision into action.

What information do you need to move forward? What problems do you need to solve? What help do you need?

We're in this together, so I'll break down my real-life example. For my decision to move to Philadelphia, I needed to understand some issues better and answer the following questions:

- *Where would I live?* My best friend's offer solved that one.
- *How would I make money?* I needed a new job. Finding one in my target industry would have taken too much time and effort. I would figure that out later. For now, I needed to find a job that provided a regular paycheck.
- *How much cash would I need to save to rent a place of my*

own? I had a temporary solve lined up, but there's only so long you can crash at a friend's place. What was rent going to cost me? What about utilities, food, and life expenses?

- *How much money would I need to make it work?* Based on estimates of rent and living expenses, what sort of hourly rate did I need?
- *How would I move?* How would I schlep my stuff to the city? I had no cash to spare on movers or even a moving truck.

That was it. That was enough to figure out.

The key to breaking down your decision into action is to keep your list of questions and issues to solve laser-focused and straightforward. YOU ARE ONLY LOOKING TO MAKE ONE DECISION COME TO LIFE. Save the rest for later.

My list focused solely on the realities of how I would get myself from my hometown to a new city and keep a roof over my head.

I did not try to figure out how to find a job in my target industry. I would focus on that goal once I settled in the new urban area.

I did not allow myself to dwell on leaving family and friends to move to a place where I knew three people. I would make new friends and connections once I got there.

I did not think about learning Philadelphia's geography, figuring out where I could long-term park my car, or how to navigate public transportation for the first time in my life. I

would figure that out when I got there.

I kept my list purely to questions and issues I absolutely needed to solve to make the move.

Keep your list simple and focused on the primary decision you've made. You will figure out the rest later.

What Information Can You Find in Existing Sources?

You have your list of questions that need answering. What might you get done with good old-fashioned research?

Google will be your best friend during this time. What *can't* you find on the internet? Some of what you're looking for may take clever searching, but keep at it. Your goal is to remove as many of the unknowns as you can.

When I considered my move to Philly, basic research helped me:

- Search job posts to get a good sense of going hourly rates for administrative jobs. It gave me an idea of the low and high ends for these positions.
- Find the information for temporary employment agencies in the metro area, including contacts to set up interviews. I didn't have the patience to wait for a full-time job to happen; I knew I had to move before my courage to do so disintegrated. Temping was the most reliable way to earn a paycheck in a new city.
- Perusing classified real estate ads gave me insight into rents in the neighborhood where my best friend

lived. Based on this information, I could estimate what hourly rate I needed to pursue.

Did I mention I did all of it without internet? My research led me to the local public library, newspapers, and, yes, even the Philadelphia Yellow Pages. It got me the information I needed at the time to better inform myself and make a move possible. You are lucky to have so much information easily and readily available to you; use it to its best advantage.

But don't forget to think beyond the internet. Which books or podcasts might have relevant information? Industry trade journals or events? Community college courses? Are there people you know who can give relevant advice? Or someone who might connect you with others who can offer the insight you need?

You're resourceful, so I know you will use all the weapons at your disposal. Your mission is to answer as many of the questions as you can so you can move from a DECISION to ACTION.

What Can't You Research in Advance?

I hate to break it to you, but you cannot solve everything on your list of concerns.

Life would be much easier if it came with guarantees. But where's the fun in that?

Solve what you can. And acknowledge that you cannot solve everything. Preparation can only take you so far. Then it's up to you to leap anyway.

Based on my experience, I was counting on getting work from temporary employment agencies. I didn't know much about them. Which ones would deliver great results for me? Which ones wouldn't? This was pivotal because my entire livelihood was relying on this point. I had no contacts at temp agencies in Philadelphia, so there was no one to ask. As mentioned before, the internet was in its infancy. There were no online reviews or discussion boards to consult. I had no way of knowing which agency would be the best fit for me.

I recognized that this issue was way too important to put all of my eggs in one proverbial basket. I registered with multiple agencies. One of them had to pan out, I figured. I made a trip down to the city and interviewed and signed up with three different agencies.

Then I went back home and gave my two weeks' notice to my employer. I learned and prepared the best I could. Then I leaped.

You will work hard to prepare the best you can.

But you will have questions you can't answer at this point. It will make you nervous. It will scare you. It will make you second-guess and doubt yourself.

Every key decision you make will bring these kinds of feelings. Embrace them. They signify that what you're doing is meaningful and worthwhile. These feelings will make your earned successes and the journey itself all the more exciting along the way.

Acknowledge and accept how you feel. Experience it. Then give yourself permission to leap anyway.

I was exhilarated and terrified. I was torn up about leaving my family behind but thrilled to get closer to my old college friends. I was sure I could fake it 'til I made it at a job, yet I was concerned that I would be seen as a total fraud at my first temp assignment.

I allowed myself to experience it all. I'd journal when I felt anxious. I sought out pep talks from supportive people. I prepared the best I could. My plan was not 100% foolproof. I acknowledged it, embraced my fear, and went for it anyway.

You can do this, too. You know you can.

If you overthink it, you will get stuck.

Take stock.

Bulletproof your decision the best that you can.

Then leap.

Hack #4:
Train Your Brain to Be Positive

You know in your heart that you are making steps toward the right end-goal.

But why can't your brain get with the program already? The sleepless nights, the constant worry, the endless *what-ifs* pacing around your head.

It happens to us all as we ponder making big changes. Your brain is trying to protect you, in the most basic *fight-or-flight* way. It senses danger; it's trying to shield you. It's freaking out and sending you *stranger-danger*, flashing red-light kinds of signals. It means well, but it can really trip you up and make you doubt yourself.

You can get your brain to calm down through meditation, yoga, or other ways of bringing mindfulness practices into your life. I wish I could be your Zen master, but I've never been successful at bringing these regular practices into my life. I wish I could. I will keep trying. If you are able to incorporate mindfulness into your everyday routine, you absolutely should.

But I have a hack for those of us who have tried to meditate

but spend the whole time thinking, "How long do I need to do this?" and "God, I really suck at this." It doesn't involve a yoga mat or a special class.

It's a powerful brain hack known as the positive mantra.

I cannot tell a lie. I will admit if you told me to repeat positive mantras when I was your age, I would have suggested you get the eff out of my face.

Search the web for old *Saturday Night Live* skits with the character Stuart Smalley. That's the person I thought needed affirmations. Not me.

But as I got older and kept hearing about the power of positive affirmations, I decided to give them a try. It turns out they are helpful, especially in times of elevated stress or anxiety.

Sometimes you need a little confidence boost. Sometimes you are down on yourself. And sometimes you are going through a rough time and can't see your way out. I've found that having a positive mantra helps.

What's a mantra? In simple terms, it's a brief sentence or phrase you repeat to yourself. The words remind, coach, console, or inspire you. The best ones do all of those things.

Mantras can be extra powerful when verbalized. You can double their power when you say the words out loud to yourself while looking in the mirror.

Mantras can also be written and displayed in meaningful ways—in dry erase marker on the bathroom mirror, a strategically placed Post-it note, a label on your laptop, or your mobile phone wallpaper.

Mantras can slip easily into your life (and subconscious). Try

using one as a computer password—how many times do you type that phrase every day? I've found this trick to be magical.

Mantras change. Words that are meaningful to you this week may not be relevant next week. Some stick around for a long time and help get you through a tough year.

Mantras are most effective when they are straightforward, easy to remember and repeat.

Think about the issue challenging you most now. Your goal is to find words that make you feel like you can beat your challenge. Like you can be the person you imagine.

Find words that speak to you. Write them on a card. Repeat them until you remember them. Keep saying them until you realize you don't need them anymore. Then find new words.

I leave you with a list of mantras. Some of them I've road-tested myself. Maybe you'll find words for you here. Maybe you'll find them somewhere else. Your goal is to find a mantra that works for you.

You *can* train your brain to be positive. It's your little secret and 100% free. Why not try it?

Sample Mantras for Real-World Feminists

I am prepared. It's go time.
I will use my voice.
I am healthier than I was yesterday.
I will speak my truth.
I am beautiful just as I am.
I will trust faith over fear.
I know what's right for me.

I am worthy of abundance.
I am in control of my choices.
I am ready for this step.
I don't know what's next, but I know it will be great.
I have everything I need.

Hack #5:

Feel All the Feels and Do It Anyway

You've done a ton of thinking and reflecting at this point. You're right on the cusp of taking that first step. As much research and work you've put in, it likely still feels scary as hell.

Good.

That's right, I said, "good." Big decisions *should* feel scary.

You don't know all the answers, but you've gotten as many as you can.

You know of all the things that could go wrong, but you need to try anyway.

You're not making everyone happy with this decision, but you know it feels right in your gut and deep in your soul.

Your emotions are on edge. One minute you're riding high on adrenaline and feeling like you can't fail. The next you're utterly terrified and frozen in your tracks.

I'm here to tell you it's all 100% normal.

This is how big decisions will always feel. Exciting, thrilling, exhilarating, terrifying, all wrapped up in one crazy package. That tremble you get going up the roller coaster hill, that *why*

am I doing this? feeling followed by the excitement of speeding down, the thrill of it all.

Soak it up. Revel in it. Big decisions and actions come with big emotions. You can't separate the pieces. It's a package deal. There's no way around it.

The sooner you can get comfortable being uncomfortable, the better off you will be. You will never reach a point in life where you won't have this tug of war of emotions. You can get better at acknowledging and managing the feelings, but they never disappear. You're a human, not a robot.

Let's take stock.

You decided what's next.

You have done your homework and learned everything you can to help drive a positive outcome.

You acknowledged what you don't know and can't know until you take action.

You know you will need to adapt and course correct when obstacles get in your way.

Your decision feels so good deep down that your heart sings as you dream of a successful outcome.

You have prepared the best you can.

But nothing more can happen until you dare to take the leap.

No one can or will take action for you.

You're not a kid anymore; it's up to you.

Don't wait for a perfect sign.

Don't wait for all the answers.

Don't wait for the perfect solution that eases your mind and calms your feelings.

Tell your doubt it's time to hop in the back seat; your badass self is at the wheel now, and you don't need their nagging ass riding shotgun.

You will not let life happen to you; you will take control and make your decision a reality.

You are a strong and resourceful person.

No one will work harder for you than you.

You will figure it out as you go.

The universe will have your back.

But only if you act.

Hack Your Job Search:

How to Find and Land Your First "Real" Job

. . .

Picture this: Wilkes-Barre, Pennsylvania, 1993.

It was about a year after my college graduation.

I had moved back to my old childhood room at my parents' house. "Free" was the only rent I could afford.

Using my bachelor's degree in film and video had translated to two hourly, part-time jobs: as management staff at the local cinema chain and as a camera operator at a public TV station.

You may think the job as a camera operator sounds like a good entry-level start, and it was for my hometown, but it paid minimum wage and most of my good hours came during the station's beg-a-thons… I wasn't exactly lucky.

Each paycheck quickly disappeared between student loans, car payments for the sexy Ford Taurus station wagon that used to be my dad's company car, weekend bar tabs, and late-night Denny's Grand Slam breakfast choices.

I was broke. Frustrated. Depressed. Confused. Stuck.

One perfect winter day, when the sky was clear, the sun was shining, the temperature wasn't too harsh, and freshly packed snow covered the ground, I was working nights and decided it

was an opportune afternoon to go sledding with my sister and my cute little nephew.

The sled just sailed down the hills that day. The snow had a layer of icy goodness on top, ideal sledding conditions. It was glorious.

On our last run for the day, all three of us piled on the plastic sled. Holy shit, we were flying. Midway down the hill, I lost my grip on the side of the sled, and my gloveless hand skidded down the ice the rest of the way.

At the bottom of the hill, I discovered my hand was a bloody mess. The ice acted like glass shards and tore up the skin. Chunks of knuckle flesh were gone. Searing white pain shot through me. We cleaned and bandaged it up the best we could, but it looked gnarly and hurt like crazy.

I worked the ticket booth at the theater that night, must have been grossing out every person as I slid tickets and change through the glass window with my bloody stump. Co-workers and friends begged me to go to a doctor. "You may have broken something!" they said. I replied by wiggling my fingers and wincing, "It's not broken. I can still move it."

I didn't have health insurance. There was no way I was spending a paycheck or two at the local emergency room. I couldn't afford it.

My mom had been on my case about finding a job with benefits. Like any mom would be in this situation, she was worried about me. I worried about settling for any job that brought health benefits in my hometown.

But the sledding incident shook me. Maybe I did need to

find a job with health benefits while I figured out my next move.

My head won out over my heart. A bank teller job opened at the branch in the mall where I worked at the cinema. I could keep both jobs and stockpile savings for a move out of the area, I told myself. Plus, I'd get insurance at the bank, so I wouldn't have to worry again about going to the doctor. A perfect plan!

I applied for the job and landed an interview right away. They already knew of my strong work ethic, my boss at the cinema recommended me, and I was a regular customer at the deposit window.

Just a few days later, I sat down with the woman who would be my supervisor and was KILLING IT. The conversation was great and I was on fire. The job was mine to lose.

Then it happened.

She looked right at me and asked: "So why do you want to be a bank teller?"

Want to be a bank teller? This question sounded so absurd that I had only one response: hysterical, can't-hold-it-back laughter.

It slowed down when I realized she wasn't laughing with me.

"Oh, you're not joking," I said uncomfortably, followed by a made-up answer.

I didn't get the job.

My subconscious torpedoed my interview. I didn't want that job. Not in a million years. No offense to bank tellers, but I couldn't imagine anyone aspiring to it. It made sense to take the job out of need, but out of desire? It was unfathomable.

Still, I needed the money, and it was frustrating to know that I'd blown the opportunity. I was disappointed for a few days, though it didn't take long for me to be thankful for my creative soul who couldn't keep quiet. When push came to shove, I refused to compromise. Common sense be damned.

You've got that fire, too.

Deep inside, you know that a job search isn't just about a paycheck or a benefits package; it's about setting out on a path that your heart desires.

But it's hard to think about making your dreams come true when you are flat-out stressed about money. You have bills that need to be paid. Savings accounts that need to be started for travel and adventure. And a little disposable income sure would be nice for a change.

You *can* have both. A job that makes your heart happy *and* pays the bills.

No matter what industry you are targeting to enter, there's one thing you can count on. Competition will be fierce. There will be many others gunning for the same positions as you.

You need to come at this hard.

You need to give it your all.

I'm here with practical advice and tools to help you get one step ahead of the pack.

It's time to hack your job search.

Hack #1:

Forget About Money for a Moment. Seriously.

You have bills to pay. I get it.

You need to set your worry over paying them aside. For just a moment.

Your job search can't only be about a target entry salary you have in your head.

It will take more than money to make you feel happy and satisfied at work.

If all people needed to be content at their job was a great paycheck, the world would be a happier place.

Sure, we need cash to cover life's necessities. Rent's due on the first of the month, and those student loans won't pay themselves.

But do you know what happens when money is the sole reason you take a job?

Your anxiety level will initially decrease; after all, you are an independent adult taking care of your bills, and that feels great.

Then, a little time passes, and the novelty of your new job wears off. That's when the nagging feelings will set in. An *"Oh*

my God, is this all there is?" feeling. A *"Did I go to college for this?"* feeling. A *"Holy shit, I need to do this for another forty years!"* feeling.

I know this from first-hand experience.

You may panic, wondering how you will translate your college degree into cold, hard cash and a roof over your head. But I want you to do more than chase a paycheck. Life is too short to live it on autopilot, and way too many people settle for good enough. You've found this book, so I know "good enough" isn't good enough for you.

You want to embark on a career path that will have twists and turns, victories and defeats, and challenge you to become a better person. You want to work with people who excite and inspire you. You want a boss you can learn from and respect.

Don't fret. I will not ask you to choose between money and happiness. I call bullshit on this way of thinking. We will get you compensated well. (More on this topic to come later.)

But for now we will focus outside of a dollar figure, and help you home in on what will make you feel satisfied as you earn that check.

Get out your notebook; it's time for another journaling exercise.

I want you to set your phone timer and give yourself ten minutes to write answers to each question. Any less, and you're not digging deep enough. This will get difficult around minute number two, but I want you to keep writing until that timer goes off. Even if you have to write, "I can't believe I have to write for another eight minutes," get it on the page and keep going.

I've added thought starters to get your mental juices flowing. Express your raw thoughts. Do not edit them; let them flow.

Question #1: What type of boss do I want?

- What sort of career has my ideal boss had?
- What would I hope to learn from my new manager?
- How would I describe the relationship I had with my favorite professors or former bosses? What about these relationships clicked?
- Do I prefer a hands-on manager or one who will give me space?

Question #2: What work environment would I thrive in?

- What does my ideal workspace look like?
- Would I work better in a competitive or collaborative environment?
- Do I think I'd be happy in a traditional corporate office, or would a non-traditional setting be more appealing?
- Is it essential for me to work with peers in my age group?
- Do I want to target a large corporation, or would I feel more energized in a smaller company?

Question #3: How would I define my work style?

- Do I thrive when working on independent projects?

- Am I a successful collaborator on group projects?
- What coaching and feedback do I need to stay on track?
- When have I felt most successful, and why?

Once you finish, reward yourself with a break. Seriously, walk away! It's important to give yourself a little time to let your thoughts marinate. Sleep on it and give yourself at least twenty-four hours before you go ahead with the next chapter.

Let's plan on picking this up tomorrow. Deal?

Hack #2:

Start Your Job Search with Clear Intent

You have pages of notes and are likely wondering, "What am I supposed to do with this mess?"

All that passion you poured out on paper holds the keys to figuring out what kind of job would make you happy.

Now you will filter it down to its core so you can start your job search with clear, defined intent.

You will not just hope that a perfect opportunity comes your way. You will drive your search and find satisfying job opportunities that fit *your* criteria.

Read over your notes. As you review, you will notice themes emerging. What did you keep repeating? Did you feel compelled to write in all caps or underline? What thoughts did you punctuate with exclamation points? Circle or highlight any patterns you notice.

These recurring themes will help you to define boundaries for your job search. Some answers trigger an emotional reaction—in a positive sense or as a "deal breaker"—pay super close attention to those.

On a new sheet of paper, answer the three questions again. But, this time, I want you to edit each answer down to one sentence, based on the freewriting exercise.

You will complete the following three sentences:

I would like to work for a boss who:

_____.

I would like to work in an environment that:

_____.

I work best when:

_____.

Hold on to this piece of paper. It will come in handy in two ways:

> 1. You have identified your ideal work setting and can use the criteria to judge opportunities that come up in your job search.
> 2. You will use these sentences to help you weigh job offers. (Like I said earlier, a paycheck isn't everything.)

You may be lucky and find a job that scores high on both salary and the criteria you set above. More likely, it will hit a few marks and you'll accept the position anyway. That's okay. You're going into a situation with your eyes wide open. This awareness will help you keep perspective and find ways to manage potential shortfalls.

You're just about ready to jump into researching job opportunities. But here are two more things I want to ask you to do before you begin. One will sound logical, the other a little crazy. Hear me out on this.

Save the Date.

First, you need to set a specific deadline for yourself. Sure, it will feel a little scary committing to an actual date. Do it anyway.

A quality job search takes time. Some companies will invite you (and all their other candidates) in for multiple rounds of interviews before putting out an offer. Your deadline should consider those realities. A month is not a realistic deadline and will cause you panic all month long. Two months is bold but doable. Three months feels about right.

Scan the calendar and pick an exact date.

Speak Your Ask to the Universe.

Yeah, I told you it sounded a little crazy.

This is a powerful step. Speaking your ask out loud will help make it more real in your mind. Repeat it to yourself. Seriously, state your intention every morning to keep your head in the game. So much of the tension and anxiety we have is self-imposed. Reflect on your mission every day.

I will secure a job as a/an _____
at a _____ working with a boss
who _____ by [date].

Here's an example of how this can play out. Say you are a graduate with a marketing degree looking to break into an advertising agency. You may state something like this:

> *I will secure a job as an Account Coordinator at a small*
> *to mid-size independent advertising agency working for*
> *a boss who is a great mentor and cares about my career*
> *growth by March 31.*

Write your sentence on an index card and read the words out loud. Keep going until you sound like you mean it.

This step is potent for another reason.

I spent years saying things like, "You know, I will debate an idea for months. But once I decide to set my mind to it, everything falls into place. Crazy, right?"

It took years to realize this dynamic was not dumb luck. It's what spiritual gurus call "the law of attraction." I'm no spiritual guru, but I will try my best to explain this phenomenon. It's a belief that whatever energy you put out in the universe you will receive back in return. If you put out positive energy, you will receive positive outcomes. And yes, the opposite is also true; negative energy will bring you negative outcomes. If you think I'm nuts, go on and Google it. Entire books have been written on this topic.

I know from my life's experiences a simple truth. Set your mind to an intention, take action, stay positive about challenges you face, and the universe rewards you. Don't expect instant results. I didn't hand you a genie in a bottle. But take a

deep breath and assure yourself that the universe will protect you if you take decisive, forward action.

If you approach your job search with negative anxiety and confused overwhelm, the universe will keep sending you frustrations until you learn your lesson.

But if you approach your job search with a positive attitude and insatiable curiosity and drive, the universe will have your back.

Believe it.

Now, you're ready to start the hustle.

Hack #3:
Hustle Every Damn Day

You know a job search will take time.

Know that it will take much more than time.

A successful job search also requires serious hustle. Focused, relentless hustle and grind until you have accepted a position.

I hate to break the news to you, but finding a full-time job is a full-time job.

You cannot think you can scan the job boards every day, send out a few resumes, and it will all work out. I approached my first job search this way. Honestly, I didn't know any better, and it seemed sensible. I'd see a classified ad that looked interesting, agonize over a cover letter, and send off my resume to a nameless, faceless human resources department. Then I'd wonder why they never followed up, not even to reject me. Typical rookie mistakes.

Lucky for you, you are about to get practical job-hunting advice from someone who not only figured out how to navigate the process herself but is also a hiring manager who has interviewed and hired hundreds of job candidates over the

course of her career.

Believe me when I tell you that step one of any job search has to begin with putting yourself on the right, winning mindset. You know the ingenuity, creativity, and drive that you plan to bring to your future employer? Infuse your job search with that energy. You need to treat finding a job as your first real job. A true forty-hours-a-week job.

I know what you're thinking. *"Forty hours a week on a job hunt? Come on!"* But, hear me out. Would you buy lottery tickets and hope it provides you with a retirement plan? Of course not. You can't just sit around and hope for the best. Apply the same logic to your job search. The job market is competitive; you can't wait for someone to notice you. You will need to make it happen. This is no time for passivity!

You are on this planet to stand out for your unique talents and perspectives. This is the person I want you to remember who you are: powerful, undeniable you. This is the person who needs to drive your job search. Get out there and get yourself noticed.

Got it? Great, now let's break it down and make it happen.

Remember your ask for the universe? That is your perfect starting point! By now, you should have it written on an index card or typed in a note on your phone. I hope you repeated it out loud enough that you can state it without looking at it. I want you to use the note as a touchstone each morning or any time you are feeling unsettled and down about your job search. Stay focused, Grasshopper. You got this.

It's time we let others in on your little secret. This means you

need to talk about your ask to other people. *"What???"* you may wonder. *"I thought they were my innermost thoughts."* Nope. Not anymore. It's time to make them known!

"But what if I'm not able to do it? I'll have to tell them if I fail."

STOP THINKING THIS WAY.

This is not a healthy or productive headspace.

It will hold you back.

Just stop.

Talk about your ask to family, friends, former classmates, favorite professors, the gal who lives down the hall, etc. You have no idea who knows who, who knows a company that sounds like the one you described, etc. Talking with others about an issue helps beyond getting moral support.

If you want the universe to lend support, you have to put yourself out there and make your ask known.

It's also time to unleash the power of the interwebs! There is no shortage of online job postings; time to hunt.

Of course, it's a natural warm-up to peruse some of the major job sites, such as:

- **Indeed.com:** This site's popularity with job seekers and employers makes this a natural place to start. It crosses all industries and geographic areas and has become the go-to place for people in search of a job.
- **Monster.com:** Before there was Indeed.com, there was Monster.com. Don't let that turn you off; it's still relevant. Like Indeed, it has a far reach across industries and areas. You will turn up different results, so explore both.

- **Google for Jobs:** The ubiquitous search engine has added functionality to make searches for job posts easier. Try very specific search terms and see what turns up.
- **Wayup.com:** This site focuses exclusively on entry-level job and internship postings for college students and recent grads. Umm, hello. It's practically calling your name.

When you find postings that pique your interest and sound like they could be a fit for your skills and background, do not apply blindly. I want you to dig into the hiring company first.

Start on their company website. Does the company look legit? Feel out their offerings and how they position themselves in the marketplace. What are their values? Do you find them exciting? Do they give you a sense of their company culture? How do they talk about their employees? Who do they typically hire? If the information is speaking to you, you're onto a hot lead.

Next, see if there's any dirt you can dig up on the company from their employees. A handy place to find this type of information is **Glassdoor** (glassdoor.com), the Yelp for employers. Take what you read with a grain of salt, though. Just as you wouldn't accept every review on a restaurant at face value, keep this in mind as you read employee reviews. People are most motivated to write a review when they have an ax to grind, so every place will have bum reviews. Look at the average total rating and how many ratings they've received, and pay attention to common themes in review content.

Does the company meet your criteria? Great, sounds like a

place where you'll want to apply for a position. Not sure? Give it a shot anyway. You can learn more about the company and its people during an interview. *At this point, you will only cut companies who violate one of your deal breakers.*

Looking for job postings is an obvious starting point, but I also want you to flip the logic and define your target companies. See beyond the organizations who have an active posting on the job boards and be proactive about determining where you want to work.

Find as many employers as you can in your target industry and geographic area. Go beyond simple search terms, too. Check to see which companies are winning awards in the industry. Search for industry-specific professional organizations and publications. Often, these sites have company directories and job openings you won't find on the big job websites.

Search for the "best places to work" in your state. See which companies on the list fall within your industry and keep those places in your crosshairs.

Once you have these targets in mind, look for opportunities. Most companies will list active job postings on their site. Keep stalking these boards because they change daily.

Maybe no open positions are available at your target companies. Don't ignore them. If you are passionate about a company, see if you can find out the names of their recruiters. The best place to search for this information is **LinkedIn** (linkedin. com). I've never met a recruiter who wasn't open to meeting new people. Send them an invitation to connect, introduce yourself, and explain why you are reaching out. Don't just

say you are looking for a job; succinctly explain why you are interested in their company, and state you would love the opportunity to connect for an informational interview. You are not overstepping in making a move like this; you are pursuing your career ambitions. Don't forget that. It's business, not personal.

Keep in mind: not all the great jobs are at the big dogs in town. So be open to start-up and small company opportunities. There are always challenger brands looking to make a mark in the industry. Start-up environments come with looser job descriptions, meaning everyone needs to work outside of their official job description. That can be an outstanding learning environment, especially for an ambitious person like you. These companies are often more willing to take a risk on a smart, entrepreneurial person at the start of her career, just like you.

Sure, these environments come with more risk—the company could crash and burn, but they could also be the next Google or Amazon, and you're in on the ground floor. It's a crapshoot, but one worth considering, especially early in your career. You're young; you have plenty of time to bounce back if it goes under, and you'd still walk away with new, marketable skills. Keep these challenger brands in your sights.

Last, you need to stay curious.

Keep looking.

Keep searching.

Keep talking to others.

Keep hustling.

The world changes daily.

Opportunities open daily.

You can make new connections daily.

People you know make new connections daily.

You get the point.

Seek out opportunity every damn day, until you have a signed job offer letter in hand.

Hack #4:

Craft A Resume That Stands Out

You think you've put together a solid resume.

I know you can make it even better.

Recruiters and hiring teams review countless resumes every day. So many of them read as *blah-blah-blah.* Copy-and-pasted business speak. Unauthentic, meaningless buzzwords. Basic.

You are not basic.

Make sure your resume shows the world that truth.

It takes hard work to craft a resume that stands out. You're up for it.

But I hate talking about myself. It feels so awkward.

You need to get over that *right now.*

Women undersell themselves every damn day.

STOP IT.

I know you are fighting against years of cultural conditioning and perhaps your own insecurities. I felt the same way. I *hated* talking about myself. It took me far too many years to get over it.

We are holding the women's movement back by thinking

this way.

More importantly, we are holding ourselves back by thinking this way.

Fight against your urge to hold back when speaking about your own experience and ambitions.

Put it out there for the world to see.

Start with your resume.

Think of your resume as your calling card. Your goal is to make people want to meet you after they've read it.

In my career, I've reviewed thousands of resumes. Not just as a hiring manager, but also, oddly enough, one of my first jobs in the big city was at a career center where I helped people improve their resumes. So I know a thing or two about the subject.

It is possible to create a resume that stands out, even as an entry-level candidate—*especially as an entry-level candidate.*

Strong communication skills are a plus for any position, and a well-written resume shows excellent written communication skills and can give you a much-needed edge. Allow me to break down the elements of a resume, and how you can make them work hard on your behalf. I'll keep my advice straight to the point. We don't have time for sugarcoating or sprinkles; you have work to do.

Contact Information:

Keep this clean and simple. No extraneous information. Use a personal email address that sounds professional—I am talking to you, *BeErGaL* or sororitysis2018 or eaglesfan420.

Objective:

I'll make it easy for you: don't bother. Your objective is to get a job; they get it. Anything you craft will sound like copy-and-pasted garbage. Skip it.

Summary:

Again, if you are entry-level, don't do it. If you have less than five years of professional experience, don't do it.

Executive Summaries can be used effectively in two potential scenarios:

- If you are highly seasoned (ten-plus years' experience) and need to speak directly about what makes you unique.
- If you are making an industry change, and you need to help an employer connect the dots between your experience and the new industry.

Everyone else should avoid it. It's a waste of precious real estate.

Education:

If you are at the start of your career (five years of experience or less), keep this near the top of your resume. You should move this down to the bottom of your resume later once you have years of professional experience that will speak for itself.

If you graduated with honors and Dean's list, include it. Same goes for any academic awards, scholarships, etc. These items show you didn't just get through school, you excelled.

Focus only on academic achievements here. Any other experiences you gained will go in later sections.

Professional Experience:

Here is the main course of your resume and where you should focus the bulk of your efforts and energy. Make every word count.

Stack your most relevant experiences at the top of this section. Paid or unpaid, it all goes here. I hope you hustled and had as many internships as you could manage during your school years. Make them work hard for you now.

When writing about each job experience, don't just describe tasks! I repeat, don't talk about your experience like it's a to-do list. Potential employers don't want to read a job description; they want to know what sets *you* apart.

For each position, I need you to pause and think. What did you achieve? If you can't answer that question, you are undervaluing your contributions and need to think harder.

What made you feel proud? Was there a specific goal you accomplished? Did you play a key role in a major initiative? Did you present a new idea that was implemented? Did you win an award? This is the content that will make you stand out from the rest. Make it as specific as you can—even better if you can attach a real statistic or measure to it.

Now, I want you to look at your draft through another lens.

Review the official description of the job you are applying for. Are there necessary skills mentioned that you haven't included? Add them in! Also, consider the specific words they

used to describe the job requirements; there may be better vocabulary choices to incorporate into your resume. It's a bit of a Jedi mind trick to make it sound like you speak the same language.

I suggest looking at your resume with fresh eyes for every position you want to apply for. Sometimes, it's helpful to have a few different versions of a resume so you can target each opportunity in the best way.

Volunteer and/or Unpaid Experience:

As I stated earlier, it won't matter if the experience you've gained was paid or not. If you have volunteer experience that shows skills you need for the job, by all means, describe them here.

Even if volunteer experience can't correlate to skills required for the job, include this information anyway. You're a human being contributing to causes you care about; be proud of it!

If there were college organizations where you made a difference, don't forget to include these contributions, too. This is particularly relevant if you held any leadership positions.

References:

Don't waste space listing contact names or telling an employer that references are available upon request. Trust me, if they want them, they'll ask.

General Advice and Watch Outs:

• Be a ruthless editor. Avoid unnecessary words like "very." Make sure you aren't repetitive or overusing terms; make the thesaurus your friend. The best way to be a ruthless editor is to walk away from the draft for at least twenty-four hours before you go into editing mode.

• Spell check! Proofread! Proofread! Proofread! Have a friend who's skilled at grammar review it, too. Typos and misspellings are cringe-worthy mistakes. Some people will toss your resume based on this point alone. I've seen it happen.

• Stick with a classic and clean design. You want people to pay attention to the content, not the font you used.

• Don't use strange bullets or characters. You know how emojis and symbols get funky when you send Android to iPhone? That kind of stuff can happen when you send any kind of electronic document.

• Make sure line spacing and line breaks are consistent throughout the document. Left-justifying core content looks cleaner than full.

• For entry-level experience, try your best to fit on one clean page. If you have the experience to fill out more than a page, expand to another. NEVER go past two pages. I'm getting bored just thinking about it.

• If you are working in Microsoft Word, check your document properties. For example, if you used a friend's resume as a starting template, you don't want her name appearing as the document's author. Most people won't look, but do it just in case. Leave no detail unchecked.

- Don't forget to make sure your voicemail outgoing message sounds professional. Mention your full name in the recording so that recruiters can be sure they dialed the correct number.
- If you are applying for a position in a city where you currently aren't located, explore using a local address on your resume. For example, I used my best friend's address in Philadelphia on mine *before* I moved there. If you can avoid the possibility of a recruiter not wanting to deal with the extra logistics of a non-local employee, you want to do so. Line up your references now. Many employers no longer ask for this information for entry-level candidates, but you want to be ready if they do. A last-minute scramble will stress you out later.

You need a compelling resume to get the interview. Mediocre resumes get tossed aside and forgotten. Trust me, no one has the time to interview what appears to be an average candidate.

Make your resume represent the badass you are. It *will* get you noticed.

Hack #5:

Make the Internet Work Hard for You As a Marketing Tool

You're an old pro at using the internet. You grew up with it as part of your being.

It's become such a part of everyday life that it's easy to take for granted.

It's the perfect time to remind you that you can use it as a powerful marketing tool. For yourself.

You can harness this power and make both your professional and personal online presences work hard for you in your job search.

The obvious place to start is the creation of an online professional profile. You've written a resume you're proud of. Now let's make it work for you online.

LinkedIn (linkedin.com) has become THE place to showcase your professional profile. As workplaces evolve, I predict that the LinkedIn profile will replace the resume. I love it as a tool to stay connected with my professional contacts and use the site at least a few times a week. LinkedIn is an excellent platform for connecting, keeping up with industry news, and

showcasing your talents, so I encourage you to get your profile live as soon as possible.

Although much of the content you've written for your resume can be re-purposed on your LinkedIn profile, this platform provides specific value-adds you should use to your best advantage.

The first place is your **headline**. You have 120 characters, and you should use each one to your advantage.

Don't just state you are an "entry-level candidate" or list a job title such as "account coordinator." You can do better than that!

For example, you could state: *Ambitious & driven advertising grad seeking opportunity to support your team in an entry-level account management role.*

You will use your own words, of course. That's how the *you* comes through. But, I will break down the 118 characters in my example.

"Ambitious & driven" = provides insight into your personality.

"Advertising grad" = provides insight into your experience level and industry you are targeting.

"Seeking opportunity" = states plainly that you are actively looking for work.

"To support your team" = demonstrates that you are such a good team player, you are mentioning it here. Your professional experience may be limited at this point; being a great team player is always a plus as an entry-level candidate.

"In an entry-level account management role" = provides insight into exactly the type of position you seek. There are many entry-level roles at any given company; narrow the scope

to the kind of opportunity you are looking for.

The second area is your **summary**. Now, you might think, wait, you told me a summary wasn't crucial to my resume. That is correct. We are talking about your online profile now, and there's one key reason to use it here: to *make it searchable.*

Simply put, you want your profile to come up in recruiter searches. You can stack the odds in your favor by using key search terms to your advantage. Keep track of words that show up repeatedly in the job postings you are interested in and use these terms in both your headline and your summary. Be sure also to reference the industry you are targeting; these are key-words that will help the right recruiters find you.

Your summary does not need to be a number of paragraphs long. Early in your career, one well-written paragraph will do the trick. Pause and breathe for a moment. What makes you special? Why should an employer take a chance on you? Don't tell them what you think they want to hear; remember, you are not basic. Intrigue a reader into wanting to know more—make a reader want to meet you.

A well-crafted headline and summary can make a difference in getting you noticed. Others may toss away these opportunities, but you won't. You will use them to your best advantage.

You're probably wondering if you need a LinkedIn profile photo. Why yes, you do. Select a photo that puts your best professional foot forward. For example, if you are applying for positions in a typical office environment, don't post a picture of yourself standing on a beach. Save those photos for Instagram. Make your profile picture a nice headshot. You don't need a

professional photographer to make it look legit. Dress like you would for an interview and get a friend to snap a photo. Selfies can work, provided you make it look like someone else took it. Do I need to tell you no duck face, no extreme angles, and no crazy filters? Look pleasant and don't forget to smile.

You also can use your cover photo to show your personality. Again, keep it professionally focused. Do not post a picture of you and your friends. Do not post anything political that may turn off a potential employer. I know you have strong beliefs, but there is a proper time and place for everything. Remember, I'm trying to help you hack the system. Your professional profile is an online resume. Keep it focused in that way. Make it *you*, but remember to make it *professional you*.

By all means, use your online profile to link to anything you want to show off. If you have a personal website that showcases your work, include it. If you have online writing samples, give context and link out to the live pieces.

Did you know you can customize your LinkedIn URL? Now you do. A URL that states your name looks more pulled together than a sequence of random characters. You can use this URL in other places, such as your email signature, resume, and other online presences.

Apply the same basic logic about building your LinkedIn professional profile to other online locations; get your information out into the wild! The no-brainer job boards like **Indeed** (indeed.com), **Monster** (monster.com), and **Wayup** (wayup.com) are a great start, but also look for industry-specific opportunities to post your profile. Don't forget your alma mater.

Do they have an alumni directory? Get your information out there!

Okay, we have covered the basics for your professional online presence. Now I need you to take stock and assess your personal online presence.

Here's the thing about the internet... there is no designated, quarantined area where employers go. It's all free game.

I am thankful that social media did not exist while I was in college or when I was starting my career. I shudder just thinking about the dumbass things I would have posted.

You are not that lucky. Social media is a blessing and a curse. Forgive me, I'm going to get bossy for a moment, but it's for your own good.

I'm giving you a new Golden Rule for Social Media:

If you wouldn't want your mother to see it, don't post it.

Yes, even on Snapchat.

Once it's out there, it's nearly impossible to take it back. Screenshots can be saved and re-posted by other people. It's hard to delete a regrettable post once it's lived online.

Go out.

Have fun.

Live your life.

Just don't post it all online.

Have a tequila shot.

Have three.

Just don't post it online.

Hone your kegstand skills, but aggressively un-tag yourself the next morning.

The world doesn't need to know about any of it.

It's time to do a digital scrub. If you think potential employers won't look at your personal profiles, you are mistaken.

Brace yourself for my best advice on this topic:

Your Facebook profile should not be open to the public. Limit it to friends-only access at once.

- While you're at it, stop and think. Do all of your Facebook "friends" need to see your private life? I'm not telling you to un-friend them, but consider categorizing people you don't know well into a group like "acquaintances." Set your default setting for posts to share with your friends but not acquaintances. If there's stuff you want to share with everyone, you can fix that with a simple couple of clicks on that post.
- Be smart about your profile and cover photo selections; these are always open to the public. I don't care how refreshing the beer was; we don't need you holding it in your profile photo.
- Take a hard look at your Instagram feed. If you have evidence of offensive or dumbass behavior, delete it. That photo of your Halloween costume where you were a sexy nurse—yeah, that needs to go, too.
- Remember, people won't get a notification if you un-friend them on Snapchat. I know you had fun that one night and felt like you needed to link up with your new tequila-inspired BFF. But have you talked to

them since that night? Maybe it's time to make a few of those connections disappear. They don't need access to your private life.

You wanted help in hacking the system, right? I didn't promise you that it would be easy, and there are aspects of perfecting your online presence that may feel like a slap across the face.

"I just want to be me," you might be thinking. *"Why is she making me edit myself?"*

I want you to be yourself.

But I also want you to use common sense.

The world (and your future employer) is watching.

Hack #6
Send Your Job Application to an Actual Human Being

You've written a kick-ass resume and have applied online for a number of positions. You have the qualifications, so why no response? *"I mean, WTF? They aren't even reaching out to reject me!"*

I'm here to assure you that you're not the issue.

It's the way you applied for the job.

"Huh? The job posting said I could apply on the site. I did what they told me to do."

Yeah, about that...

I'll explain. Submitting your resume via an online application tool or to a generic email address (for example, hiring@company.com) is what I refer to as a **cold application.**

I need you to brace yourself for a hard truth.

Cold applications = DEAD applications.

It's not the equivalent to tossing your resume in the company trash bin, but it's close.

If a scientist claimed a black hole in the universe sucked in all cold applications never to be seen again, I could be persuaded to accept the theory. I don't quite understand the

dynamic myself. Whether it's the volume of applicants, poor database management, broken hiring processes, or a combination of these issues, cold applications have a nasty habit of disappearing.

Do people end up getting jobs this way? Yes. But some people win big at casino slot machines, too. A lucky few get noticed through their cold online application. I can't explain a formula for their success when it's dumb luck.

Luck is not a strategy.

Fortunately, there is a hack to help you beat the system. It will take some hard work, but you are up to the task.

Your mission is to find a REAL, LIVE HUMAN BEING to help get your resume into the right hands.

The best way is to find a person at the company who can make sure your resume finds its way to the right recruiter, especially if it's a personal connection. You only need to find someone willing to get your resume in the right hands. They don't need to be your best friend; they just need to invest enough to get it in front of the right recruiter or human resources contact.

This strategy works best when the role you want is open, but it never hurts to ask your contact to submit your resume if they understand the kind of position you want.

Let's say you find an ideal job posting online. Before you send a cold application, try to warm it up via a personal connection.

Here are some ideas to help find a connection to help:

- Talk it up! Bring it up in conversations with your friends and family. Do they know anyone who can help?
- Harness the power of Facebook. Post a status that says, "I'm interested in a job posting at Company X. Know anyone who can help me make a connection?" It may shock you to discover who has connections you'd never guess.
- Search on LinkedIn to see if you have a contact in your target company. Sometimes you luck out and discover a direct contact willing to help, but the second- and third-degree connections can be helpful too. Your chances of getting help decrease the further out the relationship goes, but it's worth trying.
- Search LinkedIn to find recruiters or human resources contacts at the target company and send them an invitation to connect. Once you are connected, be direct and specific about what position you are interested in and ask for their help in getting your resume to the right recruiter. Recruiters help each other.
- Explore the company's website. There's usually a section about their employees. Look for a recruiter, or an HR or department head contact to email.
- If all else fails, call the company's main line, be friendly and pleasant, and try to secure a contact name and email address from the receptionist. Your chances of getting an answer are better at a small to mid-level size business. Large corporations have formal procedures that will prevent names from being given out.

But if your online research turns up with no good leads, it's worth a shot.

Many companies incentivize their employees to share referrals for job listings. Some companies give cold, hard cash to employees for hires made through their reference, especially in hot industries. If you get hired, they get a bonus. Employees at these companies love dropping a candidate in the recruiter's lap. This is what we call a win-win situation.

It can be uncomfortable to ask for help from people you may not know well. But consider this: most people are happy to help someone make a connection. You need to trust in the good in people, too.

It's a small world; you'd be surprised by who knows who.

But you have to ask to find out.

Hack #7:

Harness the Power of Your Human Connections

You've got a powerful weapon that can help you with your job search.

It comes in the shape and form of all of the human connections you already have.

Think about the power of human connection in your life. Your friends and family, yes, but now look beyond the obvious. What about the group you collaborated with on a class project that made working on that all-nighter bearable? Or the gang of pals you met in the back row of spin class. Think about the regular barista who knows your order before you say it and how it makes you smile every morning.

The power of human connection is undeniable. It's what makes life sweeter.

Now imagine if one of your spin class pals or your barista friend asked you to help them make a connection. You would, of course, say yes!

You see where I'm going here, right?

Networking is about harnessing the power of your human

connections. Your web of human relationships contains a wealth of possibilities. Yes, even professionally. Your contacts may work in a field that has nothing to do with your target industry, but you don't know whom they know. And just as you would be glad to help them, they would be glad to help you.

You already have an influential group of connections in your life. Seriously, you do. Even starting out. Even if you don't know anyone in your target industry. You have a web of human connections who'd love to help you out. A practical way to wrangle them up is through your LinkedIn profile. You need to connect with as many of them as you can find.

Find the college classmates that fell in your regular circles. Connect with all of your relatives—it's strange to see them as professionals when you've seen them at family reunions at their best and worst—but they are people with actual careers and contacts that may be helpful. Connect with your favorite professors who would know you by name; connect with your neighbors across the street; connect with your hair stylist. You get it. Connect, connect, connect!

There will be names that come up that you are unsure about. As a general rule, ask yourself, *"Would I be willing to help them make a connection?"* If the answer is yes, then send an invitation. If not—well, you have your answer.

Now you have created an online web of connections that you can refer to throughout your job search.

Of course, we're not going to settle for corralling just the people you know.

You can do better than that.

You are going to expand your network and start making new connections. This is especially important at the start of your career. So, let's say you hear about a networking happy hour related to your target industry or thrown by your college alumni association. By all means, GO. What else are you going to do, anyway—go home and catch up on Netflix? Get out and meet people.

"*But I hate networking,*" you may be thinking.

I feel you on this.

The word "networking" used to feel like a dirty word to me. It conjured up mental images of being in a happy hour with mediocre food and worse wine, surrounded by chatty people who want to brag about what they do.

I used to think, "*If this is what it takes to get a great job, I'm screwed.*"

If you commiserate, here's the good news. "Networking" doesn't need to be this way. I want you to redefine it as "connecting."

I'm an introvert by nature, but I can now attend a professional event without dreading it. Here's what I've learned.

First, don't think you have to meet as many people as possible! A five-minute chat with someone before asking for her business card is not making a quality connection. It's the opposite.

Look to connect with just one person. That's it. If I walk away from an event feeling like I had an enjoyable conversation with one person, I deem it a success. I want to have a real dialogue, and you should, too. Tell yourself that your goal

for the event is to meet one person, and you can't leave until you've done so.

Once you arrive, get a lay of the land. Scope out people you think you might vibe with. Pick up a drink or snack and relax. Then go for it. Break the ice with a simple hello and by introducing yourself: "This is the first time I've come out to an event thrown by [name of organization]. How about you?"

Now, I want you to listen—really listen. Too often, we get so hung up on what we will say next that we stop listening. Connection starts with *active listening*.

Ask questions. Listen more than you talk. See if you can find out what makes the other person tick; make it a mission to learn what you have in common. Don't just ask them what they do; dig deeper. Discover what excites them. Share what excites you.

Maybe it's the start of a new friendship. Perhaps it ends up being one pleasant conversation, and you never see the person again in your life. Exchange contact information if it feels comfortable. Follow up with a LinkedIn invite within twenty-four hours of the event. In your invite, state that it was great to meet them and that you are happy to help them make any connections you can. It's about quality, *mutual* interaction, not asking for a favor.

Networking is not so intimidating when you think about it this way—is it?

Be yourself and be open to meeting new people.

It's as easy as that.

Hack #8:
Land. The. Interview.

You are bright and ambitious, and every employer wants to see a candidate with that spark in her eyes.

You can show them you're ready for a challenge, *but only if you land the interview.*

You have a passion for subject matter that will be a great fit for the right employer.

You can make them see that reality, *but only if you land the interview.*

You will bring your all every day, and every employer needs people who are wired that way.

You can show them you are a go-getter, *but only if you land the interview.*

You are more than your everyday, run-of-the-mill entry-level candidate.

You can show them you are a badass, *but only if you land the interview.*

You see where I'm going here.

It's reality check time.

All of the hacks to this point are driving to one core goal, and that is to *land the interview*.

This is the holy grail you are driving toward.

A great resume can only take you so far.

Your challenge is to *land the interview*.

You will not land the interview by meekly applying online.

You need to push yourself and try some of the hacks here.

Invent some of your own.

There are many others trying to land the same interview.

The candidates who land interviews are the ones who go the extra mile.

Strategize.

Fight.

Scrap.

Hustle.

Connect.

Act.

Do what you have to do to *land the interview*.

Stop thinking about it.

Start doing it.

You've got this.

Hack #9:
Be Ready with Your Elevator Speech

You're targeting a number of companies at this point and are laser-focused on landing the interview.

It's a good time to start preparing for a key component of any interview: the elevator speech.

Every interviewer has her own style.

Some will be relaxed, as though you're conversing with a friend.

Others will feel like an interrogation by a detective on *Law and Order*.

No matter what their style, most interviewers will start with a variation of the same question. "*Tell me about yourself,*" they'll say.

For the interviewer, this question is a warm-up and could be a tone-setter for the rest of the conversation. Your interviewers are meeting a handful of people for the same position. Your answer could be the start of setting yourself apart from the pack.

That's where the elevator speech comes in. Its basic premise is that you can introduce and summarize yourself in the time

that an average elevator ride would take.

I struggled for many years with my elevator speech. Talking about myself in this fashion made me uncomfortable. *Will I sound like I'm bragging? Are my accomplishments good enough?* My insecurities stood in my way.

I share this because it's common for women to feel the same. If the idea of preparing a little speech about yourself to say in front of a stranger makes you uncomfortable, you are not alone.

But, now it's time to get over it.

Seriously, you need to stop it.

You need to let your inner badass out.

You will not be a person who awkwardly rambles about your professional life for three minutes.

You will get to the point.

You will speak with confidence.

There is a simple framework to help you create a kick-ass elevator speech:

> **Sentence 1**: Introduce yourself and express gratitude for the opportunity to connect with your interviewer.
> **Sentence 2**: Give a crisp description of your most recent accomplishments.
> **Sentence 3**: Explain why you are here today and why you are interested in *this job* at *this company*.

That's it.

We're talking thirty seconds of clear statements, communicated with confidence and a happy sparkle in your eyes.

To make the above framework go from basic to brilliant…

- Tailor your most recent accomplishments to match the skills needed for the role you are interviewing for.
- Give a compelling reason you want *this specific job*; it shows you have done your homework and are invested in your career path.
- Smile and speak with confidence and ease.

To come off as the confident badass you are, you need to prepare well in advance of meeting your interviewer. Don't think you can make up your answers on the fly or prep them on the subway ride to your interview. Stumbling on your words out of the gate can throw you off for the rest of the meeting. Obviously, you want to do your best to avoid that unfortunate outcome.

Write your responses in detail and practice them OUT LOUD. I'm serious. As a first step, I want you to stand in front of a mirror and read your elevator pitch aloud to yourself.

You may sound awkward. And, truth be told, you will feel embarrassed at the start. But, trust me on this. As you say your speech to yourself in the mirror, you will get more comfortable and grounded in your delivery. Remember: you can't project poise when you're fidgeting. So I want you to practice until your chest untightens or the jitters in your stomach settle.

Do you know what else will help calm those nerves? I want you to keep going until you can say it comfortably without looking at your cheat sheet. Keep practicing until you realize

you don't need to recite every word the same way. I want you to be so sure of the thoughts you need to express that you can use different words and stay on message. You are memorizing the framework and the key points you want to make, not the words themselves.

Practice in front of your roommate. Practice with someone you don't know. Ask a person in a coffee shop if you can rehearse it for them. Seriously. Get used to presenting yourself to strangers.

I took far too many years to develop this skill. I didn't realize how I was underselling my experience until I had a colleague point it out in a training workshop. Do better than I did; master the art of the elevator speech now. You will need to use this skill often throughout your career.

A great elevator speech will help you show confidence and professional intelligence to a potential new employer.

A great elevator speech will give you a mental edge as the rest of the questions come at you.

A great elevator speech is a difference-maker.

Use it to your advantage.

Hack #10:

Get Past the Gate Keeper

Just when you started losing faith in yourself, *bam!*

You find in your inbox a note from a recruiter looking to schedule an introductory interview.

Bingo! You've attracted the attention of a live human being at one of your target companies.

This is what you've been working toward, and it feels fantastic!

I'll give you five minutes to celebrate.

Hug or fist bump your roommate, victory dance in your underwear, call Mom to share the news.

Okay, the party's over, and it's time to get to work.

Odds are you're one of a small army of candidates vying for this position. We need to prepare you to stand out from the crowd.

I'll start by giving you the inside scoop on the first interview.

To you, the job candidate, this first interview will be positioned as an "introductory interview" or "informational interview."

To the recruiter or potential employer, this first interview is referred to as the "phone screen." Yep, this call has one purpose: to figure out if you are worth the time for a real, live interview.

Someone on the recruitment team will conduct this interview. He or she may be the lead recruiter on the position you applied for, or part of a team supporting a more seasoned recruiter. This person will stay your primary contact throughout the process, from first interview through the job offer.

Information is power, so I'll give you the harsh truth about company recruiters.

Recruiting is a difficult, thankless job that comes with a ton of pressure to get good candidates in front of a hiring team as fast as possible.

Recruiters will have little power over whether you actually get hired.

THE EXCEPTION IS THIS KEY MEETING—the informational interview.

Think of the recruiter as the gatekeeper. If your conversation goes well, you will be deemed worthy of meeting the hiring manager for consideration.

If your conversation does not go well, you're dead in the water.

Let's break down the anatomy of a successful informational interview.

Respond quickly to the recruiter's inquiry.

First, never, ever leave a request for an interview sitting in your email unacknowledged for over twenty-four hours. You're not

playing hard to get; recruiters don't have time to chase you. My dad has always been fond of saying, "You snooze, you lose." It was usually when my mom had just set out a platter of snacks, but here is one case where his words are applicable beyond food. Respond promptly, expressing your interest in learning more about the position and suggesting potential times for the interview.

Choose your interview time wisely.

Most of the time, the introductory interview will happen over the phone or video chat. Make sure to pick a time when you can give 100% of your attention. Additionally, I recommend taking a forty-eight-hour window before the interview to prepare (twenty-four hours at a minimum).

Take the call in a quiet, private space.

Find a place with little to no background noise—and don't forget the need for crystal-clear phone reception. If you know your service is spotty in your living room, don't take the call there! Dropped calls or shouting over background noise will set you up for failure from the start. Imagine how you'd feel if the call dropped while your interviewer was talking! Do your best to ensure your privacy during the call. You will feel awkward if your roommate is hanging out in the same room, for example. You don't want an audience listening to your every word.

Dress the part.

"Why do I need to dress nice? They can't see me," you might be

thinking. How you feel will impact the way you show up on the call. Do you think you will project the confidence of a professional badass while you're sitting in an old sorority sweatshirt and pajama bottoms? Probably not. Put on real clothes. If you feel next-level fabulous in a full face of makeup, make it so. Do what you need to feel great; it will be a difference-maker in your interview performance.

Consider your best backdrop for a video chat.

If you are interviewing via Skype or FaceTime, then set up space for this purpose. It will help to sit at a desk or a table. Remove clutter from the background and make it as innocuous as possible. You want them to pay attention to you, not the setting behind you. It should go without saying that if they can see you, dress as though it were a real interview. (Because it is.)

Be seated and ready ten minutes early.

Take a few deep breaths. Repeat your positive mantras. Have notes in front of you, just in case. Have that phone in your hand. Check to ensure the ringer is on. Be available to answer the phone when it rings.

Answer the call as a professional.

Your mom or BFF is not on the other end. How would you pick up a phone at work? I suggest a simple greeting such as, "Hello, this is Michelle. Is this [insert recruiter's name]?" Set the tone and show the recruiter you are ready for business.

Do your research and prepare your elevator speech.
Your recruiter may appear extra chatty and friendly; most of them are. Don't get fooled into treating the call as a casual conversation; you need to bring your A-game. Read the sections on how to prepare and master an interview, and treat this phone interview as a bona fide, live interview. Be ready.

Close the loop after the interview.
Within twenty-four hours of the call, you should email your interviewer to thank them for their time, reiterate your interest in the position, and inquire about next steps.

You've got your potential employer on the hook.

Reel them in by showing up as your best self at the introductory interview.

Get past that gatekeeper.

Hack #11:

Prepare to Kick Some Serious Interview Ass

At long last, the recruiter calls.

They want to bring you in for an in-person interview!

Congrats, you've made it through the first gate.

Now it's time for you to meet with the team of decision makers who will decide whether to hire you.

You may be surprised to learn that you have a new ally in your court.

The recruiter.

Yeah, that's right.

At this stage, the dynamic between you and the recruiter will shift somewhat. They gave you a stamp of approval to proceed—so the interview team's perception of your candidacy is not only a reflection of you; it also reflects on the recruiter and their candidate vetting skills.

Simply put, it's in the recruiter's best interest for you to interview well.

Now, don't get it twisted. It's not like you've suddenly got a team of cheerleaders shouting on your behalf. But, the recruiter

is hopeful that you are a match and wants to set you up for a good interview experience. This is why I strongly suggest taking a call with the recruiter to schedule your interview and not just talk about interview logistics via an email conversation.

If you ask for a quick call, it's likely they will accept. Like I've said, it's in their best interest for you to show up well. Use your conversation to learn the following information:

- *Who will I be interviewing with?* Seek specific names and titles. You'll want to do a little research on these individuals before you meet them. In case you were wondering, it's not strange to confirm how to spell a name if it's unique or hard to pronounce. Go ahead and ask.
- *Who is the hiring manager?* You want to find out because this person will be the key decision maker and most likely your boss if you get hired. Believe me, this is a name you want to know before you meet this person, as opposed to after.
- *Is there a formal job description?* Of course, you want to get this information if you can.
- *Is this position new or recently vacated?* There may be some informal information you can gain about the job that the official job description won't say.
- *What can you share with me about the interviewer team?* Specifically, aim to learn more about their specific roles and how you would work with them if you get the job.

If your recruiter is chatty and open, you may get some vital information about interviewer styles or why the position is still open.

I once had a recruiter tell me in a conspiratorial tone, "She's going to be the tough one in your interview. She will come hard at you with her questions. But she is trying to determine if you are willing to do the job you are hired for and are not just looking for the next step out of the gate."

And that was precisely my experience with that interviewer. Thanks to the recruiter, I was ready for her.

There's an innocent way you can probe to see what else the recruiter will confide in you. As you are closing the call, say, "I'm very interested in this position. Is there anything you can share to help set me up for a successful conversation?"

If they are tight-lipped, you will get a generic answer. But, if the recruiter is a talker or under pressure to fill positions, you may walk away with some informational gems.

All the information you gain from the recruiter will help you focus your pre-game research. Yes, you've already researched as part of targeting this company, but it's time to take your search to the next level. You want to go in feeling prepared and confident. Focus your efforts on not just the company, but also your interviewers.

Company Research:
- Refresh your memory by reading through the company website.
- Understand their offering and how they position them-

selves in their market.

• Larger corporations usually have a vision statement or credo that describes not only their company but also the people they employ. You will be measured against these standards, so make sure you discover what they are so you can exemplify them in your interview.

• Read any recent news on the company; do this by looking for a press release section on the company website and Google for news.

• Learn who the CEO is and what he or she stands for. What are the company's values?

Interviewer Research:

• Start on the company website. The smaller the company, the more you will learn about specific individuals. If you are talking with a large corporation, you're unlikely to find much about your interviewers, but check just in case.

• Next stop: **LinkedIn** (linkedin.com)!

• Look up the individual interviewers and read their profiles. Check out their activity feed to get insights into what's important to them. They may have shared articles or written comments that will give you context into who they are.

• Do you share any mutual connections? Maybe you know someone who could speak to your work ethic or experience on your behalf.

• Be sure to view their profile in public mode, and not as a private search. Let them see you are looking. I love it when a candidate researches me. It shows they are doing their

homework.

• Google your interviewers. They may have written industry articles; read them. They may be active with a professional organization or charity. All of this is fantastic preparation for your meeting.

• Write any questions you have for each interviewer. Did they express a point of view you find intriguing? Plan to ask them to elaborate. Is there a facet of their career path that excites you? Plan to discuss it.

All of this information will put you in an excellent position for a real dialogue with your interviewers.

And psst… it'll also give you clues into how to frame your own experiences and background.

This preparation is hard work, I know.

But prepare as if your success counts on it.

Because it does.

Hack #12:

Don't Make a Rookie Mistake

You made it past the phone screener.

You've clocked some serious time preparing for your interview and you feel confident.

You *should*; you're ready to kick ass.

But I want to caution you about some basics. Some of this advice may make you think, "*Duh! That's so obvious!*" But details matter, so listen up anyway. I don't want you to blow it over a rookie mistake!

First, you need to plan to arrive at your interview early.

Not on time.

Early.

When you plan out your departure time, assume anything that could go wrong with your commute will go wrong—late trains, road construction, highway accident, garbage trucks blocking a street, hurricanes, whatever. Leave for the interview with enough time to make it through the worst trip ever and

still arrive on time.

If your plan gets you there super early—great! Find a nearby coffee shop or a place to sit for a few minutes to collect your thoughts. Do a mental run-through of your elevator speech. Take deep breaths to help you calm your jitters. Use this extra time to compose yourself.

Consider the alternative. Imagine how you'd feel if you were surprised by a terrible commute. You'd be screaming at traffic, white-knuckling the steering wheel, or sprinting around slow people on the sidewalk the whole way. Even if you arrived on time, think of your mental state. Stressed is not a headspace where you can flip a switch and show up as the awesome person you are. Don't let poor time management trash all the hard work you've put into preparing for your interview.

Plan a wardrobe selection that makes you feel dressed for the part.

Of course, you should be showing up dressed for success. But, it would be helpful also to understand how employees at the company dress every day. Check their website and social media presences—what do employees wear for a day at the office? Is it a conservative dress code of blue and black suits, or something more creative? Do they have a polo and khaki business casual style, or can you wear what you want?

Naturally, you will wear the best interview suit or outfit you have. But, your research can give you clues on how to make tweaks to suggest you would fit right in. For instance, if it's a conservative workplace, wear classic and simple jewelry. For a

more creative environment, wear your suit, but swap the blazer with a leather jacket, or pair it with an eclectic necklace or scarf that gives your look more personality.

Your best interview outfit shouldn't only check the box of what you think professional attire should be. It should make you feel powerful!

Take a good look in the mirror and be honest with yourself on fit and how it makes you feel. Is the skirt pinching you at the waist? That will not make you feel powerful. Are there gaps between the buttons on your button-down shirt? That will make you look sloppy. You want your outfit to make you feel fantastic, not insecure.

At the risk of sounding like a micro-manager, I want you to limit yourself to carry one nice handbag to the interview.

Don't bring a purse and a briefcase. Or a coffee. Or anything else you can pile on. Don't show up looking like a pack mule. Seriously, if you are carrying two bags, you are carrying too much. It's not so much about the look, but an armful of bags will make for awkward handshakes and movement between interviews. I've seen and experienced it, and it's... uncomfortable.

Don't forget to check yourself one last time before you enter the building.

You don't know what the commute has done to your hair or makeup. Make sure you have a second to check your appearance discreetly before walking up to the reception desk. You

want people to remember your conversation, not the lipstick across your teeth.

Act as though everyone you meet has hiring decision power.

Smile and be friendly to everyone you encounter. It should go without saying that you should be pleasant to the security guard, receptionist, and the human resources assistant who's shuttling you around the different offices. Be a kind person, and not just because it will help you get a job. Do it because it's the right way to be a human being.

For the love of God, please have a decent handshake!

Here is part of your first interaction with an interviewer. Make it count! People expect a firm handshake as you look them in the eyes and smile with your greeting.

What makes a good handshake? I don't care if you are a lefty; for a handshake, you are right-handed. The webbing between your thumb and pointer finger should contact the webbing of your interviewer's thumb and pointer finger. Your grasp should be firm, but not vice-like, and the shake should be long enough to make eye contact and introduce yourself by name.

A weak handshake is a turn-off to most interviewers. It sub-consciously raises the bar for your interview performance out the gate.

A weak handshake = a weak start.

You are not a princess; you are a badass.

Show it with your handshake.

Don't forget to bring copies of your resume.

Often, interviewers are prepared and have a copy present. But sometimes they are running from another meeting or obligation and do not. Make it easy on them and have extra copies ready. No need to print your resume on fancy paper; a sheet of plain white paper will do.

You've worked hard to get here.

Don't let no-brainer mistakes cost you any points.

Hack #13:

Remember an Interview Is a Two-Way Conversation
(Not an Interrogation)

You are prepared and ready to speak thoughtfully about your professional experiences.

But how do you stand out as a star candidate for the job?

You do it by treating your interview like a genuine two-way dialogue, a real conversation.

Don't just sit and wait for the next question.

You are not just here to speak to your background and experiences.

You are on a fact-finding mission!

Yes, your interviewers need to vet you.

But you have to see if you want to trust this company with the next step of your career.

This may be an intimidating thought for someone starting her career. Or someone eager to leave a position she knows is not a good fit.

You may be thinking, *"I just need a job!"*

Take a deep breath. I caution you not to allow the stress of

impending student loan bills push you into making a wrong decision. A full-time position means you will spend the bulk of your waking hours at this company. Don't let fear cloud your judgment about what's right for you and your career.

At this point in my career, I've interviewed hundreds of people.

Some of those interviews have been delightful conversations. Others were painful from the moment the interviewee sat down in my office.

The best interviews I've taken part in have been a real dialogue about the position. An interviewer knows when they are meeting with someone who is passionate about her career path. I want to feel like a candidate isn't trying to showcase only her achievements; I want her to assess me as a hiring manager and our company for fit. Any decent hiring manager will agree.

Want to know what I consider to be the kiss of death?

It's when I've asked, "Do you have any questions for me about the position or our company?"

And a candidate looks me in the eye and says some version of "NO."

Really? I want to say. *Couldn't you come up with a single one for me?* It shows me a lack of preparation or imagination. It's such a turn-off. You can't just trust your career to anyone. An interview is your time to discover if this job is the right move for you, and if you can't come up with even one good question, your interviewer will presume you don't care.

To have an active dialogue, you will need to be ready with questions of your own for your interviewers. Bringing notes

along with you is okay. I encourage you to do so. You can also use that notebook to jot down observations throughout your meetings. It's handy and sends the message to the interviewer that you are invested in the job opportunity.

Keep in mind that any person who is interviewing you has a stake in the open role. Some of their votes may count more than others, but a person rarely gets hired if someone on the team has a strong adverse reaction to her. So, you must treat everyone on your interview schedule as THE decision maker because they could be THE deal killer. No one is a toss-away meeting; you should have different questions for everyone.

What questions should you ask? Ask questions about the role and how you would work together, for starters:

- *How closely would we work together?*
- *What traits do you think would make a person in this role successful?*
- *What do you look for in a teammate?*
- *How would you describe your work style?*

Ask about the actual projects the team is working on. Learn more about what your everyday would look like.

- *What contributions would you expect from this a person in this role?*
- *You mentioned the [insert project name]. What do you think is most exciting about this project?*

And don't forget, most people like talking about themselves. Warm them up by finding out more about their experiences or what makes them tick.

> • *How has [company name] supported you in your own career?*
> • *What drew you to this industry?*
> • You've reviewed the interviewer's profile. Go ahead and ask your specific questions. What about their career path intrigues you? Ask about it. Look for changes in industries or roles and ask about why they made the change.
> • If your research has turned up an article they've written or interview they've given, bring a specific follow-up question related to it. This is the kind of question that will gain you bonus points with the interviewer.

Is any question free game? Hell no. There are several you should avoid at all costs:

> • Never ask anything related to a job offer, including questions about benefits or vacation days. Save those for your HR contact or recruiter when you receive an offer. They are the only people allowed to answer these questions on the company's behalf. Not only will no one else be able to offer the answers, but they will also be turned off by these questions.

- Don't ask about work-life balance. If you are a good listener and observer, you can surmise these answers. If you actively ask about it, people will question your work ethic.
- Avoid questions that can be answered by reading the company website or conducting a basic Google search. You will appear unprepared, at best. If those are the only questions you can come up with, you haven't worked hard enough. Dig deeper.
- The same goes for asking questions answered by reading the basic job description. Don't. Just don't.

Remember, you are just two people having a professional conversation... for which you happen to be exceptionally well-prepared.

Hack #14:

Think of Your Interviewer as a Human Being
(Not Just an Employer)

You've researched your interviewers like a good biographer or FBI agent would.

You know about their past career experiences and marks they've made on the industry.

You are ready to talk shop.

But I'll let you in on a little secret.

Your interviewer is also a real person, someone with family, friends, interests, and hobbies. Yes, sure, they have a professional career—that's why you are meeting them in this situation—but it's important to remember that their work life is only one dimension of them.

Think about it. If an interview were only about vetting your skills, why bother with an in-person meeting? They could just make you take an online test, right?

An interview is about more than your skills. It's also about fit and chemistry with the existing team. People want to hire someone they can connect with, too.

Now, don't misunderstand me. You should never assume your interviewer is looking for a new BFF or dart league teammate. But culture fit is important.

A full-time job requires forty-plus hours a week surrounded by the same group of people. Would you prefer to spend that time with people you like or dislike? Your interviewer will be wondering: *"Can I work with this person for forty hours a week?"*

Information is power, and now it's time to work this dynamic to your advantage.

Be a person your interviewer wants on the team.

Show them you have things in common.

Now, this can be done gracefully or awkwardly. To do it gracefully, you must approach your common ground as *your genuine self.* No lying or exaggerations! If you try to be someone you aren't, no one will fall for it. Besides, you want people to connect with *you*, not who you are pretending to be.

I will break down a real-life example of how you can pull this off.

There was a time when I considered going into law. I was a couple of years out of college and debating my career path. I decided that I wanted to get work experience inside a law firm to see if it was for me before I worked toward getting into law school.

The trouble was I didn't have a pre-law degree, or anything remotely resembling it. Strategically, I decided to target small firms who might give a smart, ambitious person (without a pre-law degree or legal experience) a shot. So when I landed

an interview, I knew I had to slay. My chances at a legal job would be limited due to my lack of experience. I needed to make my interview work as hard for me as it could. This meant I needed to do more than answer questions thoroughly and sell my qualifications. I had to make my interviewers like me.

I mustered up my best confident smile and headed into the first interviewer's office. Going in, I knew he was one partner of this family-run firm. It was a multi-generational business, so I correctly assumed that he came from an affluent background and had some fancy hobbies.

I was a middle-class gal from the sticks, an area so remote that my parents' home wasn't wired for cable TV until I was off to college. What did I know about growing up blue blood? Nothing!

As I stepped into his office, I did a quick scan and noticed a nautical painting and ship-in-a-bottle type knick-knack on his desk. I quickly surmised that he was into sailing—further indication that he had upper-class hobbies.

We had a traditional interview, a back and forth Q&A that I could tell was going well. As we were wrapping up, he came up with what some people might see as a toss-away question: "What do you do for fun?"

This is not a toss-away question.

It is an opportunity to connect with your interviewer. Use it to your best advantage.

What do you do for fun?

Hmm, well I loved going to rock concerts. *Maybe he'd connect with that; likely not.*

I loved reading books in coffee shops. *That doesn't sound very fun; sounds anti-social in fact.*

I strategically reached for the one thing in my life I thought he would share.

"Well, I'm learning to play tennis."

Bingo. Of course, he played tennis! Now, this wasn't a fib; I had a boyfriend at the time trying to teach me how to play. Only, we were both awful and had played only a handful of times.

Suddenly, my interviewer had a mental picture of me in tennis whites at a beautiful country club. It was far from the reality of me lobbing balls over the fence at a city playground court. But it did the trick. Now, I was a person he could envision spending time with.

Why did this work? It was the truth. I could banter about it and speak to my first-hand experience.

I could have gone for the easy lie and said I was into sailing. But that would have been bullshit, and any follow-up question would have revealed that. Then I would have been the creepy person who pretended to be a sailor.

Catch my drift? You can't just manufacture a connection. It needs to be real, genuine, and thoughtfully curated for the interviewer in front of you.

Interestingly enough, after we talked about tennis, he asked me if I sailed. I didn't just say no, I said, "No, but it's something I've always wanted to do." Another truth, but now, instead of shutting down the conversation, I discussed my desire to learn.

Now, perhaps this whole way of thinking makes you feel

a little uneasy. This isn't about playing anyone. Reframe your thinking. This is strategic advice to give you an edge. A little extra shine on top of all the great qualities and qualifications you bring to the table.

How do you approach it gracefully and not awkwardly? Let's break the keys to success.

Apply learnings from your research on interviewers.

The importance of learning as much as you can about your interviewer has been discussed in previous content.

DO connect with her interests. For example, you can refer to a professional organization they belong to; a charity they volunteer with; a professional article or blog post they've authored. You'll know about these things because you'll have visited her LinkedIn profile in advance.

DON'T go digging through her personal life. If the only way you know she shares your love of macramé is because you dove three years deep into her Instagram profile, don't bring it up.

Look for clues in your interviewer's office setting.

Just as I learned about the lawyer's personal interests from his office décor, you too can use this trick to your advantage. You can learn a lot about a person by taking in their surroundings.

DO make solid inferences about her interests based on unique items on display, such as a book on their desk that you read recently, a unique piece of art (versus a generic print you'd

see in any office), or a university pennant.

DON'T make casual conversation about things you should never talk to a stranger about, such as their family. I don't care if it looks like their kid made the coolest ashtray you've ever seen; don't mention it. I don't care if their wife bears a striking resemblance to Angelina Jolie; keep it to yourself. NEVER go down the family path. You have no idea what bad feelings you can trigger; steer clear. This talk does not belong in a professional interview.

Look for clues in your interviewer's appearance.

There may be clues about your interviewer's interests or personality that stand out by looking at your interviewer's appearance.

DO look for clues into the person your interviewer is outside the office. For example, expensive running shoes are a good hint they lead an athletic lifestyle. Mala beads on their wrist show suggest they have a more spiritual side.

DON'T comment on cute shoes, unique jewelry, or anything they are wearing. You are not the fashion police; this remark sounds superficial at best.

There's a delicate balance between making a personal connection and being too personal. When in doubt, play it safe. A creepy misstep will backfire.

And in case you're wondering if I got the job at the law firm… I did.

A couple of the months into the gig, I was chatting with one of my peers, and my interview came up.

She laughed and said, "It was down to you and another

woman. I voted for you, because we asked about what music you liked, and you said that Elvis Costello was your favorite musician. The other woman was in love with Michael Bolton. Can you imagine spending all day with someone who listens to Michael Bolton!?"

As they say in the legal world, I rest my case.

Do all of your homework before an interview.

Show up as your best self.

And if there's a way you can make a genuine, personal connection with an interviewer, go for it.

It won't get you the job, but it will give you an edge.

Hack #15:

Follow Up Until You Get an Answer

You prepared well and aced your interview.

You felt like you connected with your interviewers; you have great vibes about the company; you want this job!

Awesome, all the more reason I need you to keep going.

Now is not the time to act passively!

No sitting by the phone and waiting for it to ring. After your interview, you are going to take swift and deliberate actions.

Within the twenty-four hours following an interview, you **must**:

- Follow up directly with the recruiter or your primary point of contact. You want them to know you are interested! Inquire about the next steps in their hiring decision, including timing. It's important to get a sense of the timeline so you can direct your follow-up efforts appropriately.
- Write thank-you notes to each, individual interviewer. Yes, every single one. Don't send a mass email or copy

and paste the same message to everyone. I want you to stand out from the crowd! That will require extra effort.

A well-crafted thank-you note is becoming a lost art. You may think such simple courtesies are outdated or no longer necessary. Let your competition think this way; you will think differently.

You will use the thank-you note to express genuine appreciation, because genuine gratitude never goes out of style.

You will use the thank-you note to stand out and to keep your name top of mind with your interviewers.

If you think I'm full of it, here's a real-world example. My 22-year-old niece recently took my advice and sent thank-you emails to her interviewers, even though I could tell she had doubts that it mattered.

She learned there were fourteen other candidates interviewed before her.

She also learned that she was the only one to send a thank-you note.

She learned this when they offered her the job.

This is a no-brainer. Take the time and send thank-you notes.

I've received many thank-you notes in my career. I've forgotten most of them. But there were a few candidates who used this follow-up tool so effectively they still stand out in my mind.

Here's how you craft a thank-you note that stands out in the clutter:

- Thank the interviewer for her time, tell her you enjoyed your conversation and explain why. The more specific you can be, the better!
- Express your interest in the position and explain why you are uniquely qualified for it. Don't go crazy here and write a ton of content. Keep it succinct.
- Use your real voice! You don't want the note to sound robotic, or worse yet, a snippet you copied and pasted off the internet. Be you!

You need to make every interaction count, so make the thank-you note work hard for you.

Email is the best medium to use for thank-you notes. The easiest way to ensure that you have correct email addresses is to ask each interviewer for a business card at the end of the interview. If they don't have one available (it happens), ask your recruiter or your primary contact to confirm email addresses. I promise, it's not a weird request. Don't be shy about asking for this information.

Although hand-written notes may seem like a charming way to stand out, I discourage you from using snail mail for professional thank-you notes. I once received a perfectly crafted note written on a lovely note card… three months after the interview. Not because the mail didn't arrive—but because I rarely check my office mailbox. Few people do. Snail mail means junk mail at the office; no one is waiting to receive anything of value via US mail. Save yourself the postage and trouble.

Over the years, I've heard of stories of people sending a

unique thank-you gift to interviewers. That is the stuff of urban legend and does not reflect real life. Don't believe any fiction you heard or read on this topic. I don't care how smart you think it is—do not do it. You want to be remembered for your qualifications and personality, not some stunt that may or may not resonate.

Don't be dismayed if you don't get a response to the thank-you email from your interviewers. It means nothing. Often an interviewer won't respond because they can't. There may be a hiring rule that mandates that any follow-up conversations have to be conducted by the recruiter.

The hiring process can be prolonged. Typically, the bigger and more established a company, the longer the process takes. You want to be sure you have clear expectations on timing. This helps with more than keeping your sanity in check; it also enables you to schedule your follow-up efforts.

Listen up!

Delays in communication likely have nothing to do with you as a candidate. They usually reflect internal hiring processes or approval delays.

If you do not hear from the recruiter by the time they told you they would update you, you need to follow up with them. Seriously. Don't wait. As a general rule, reach out one business day after the deadline they communicated to you. For example, if they state that they will get back to you by the end of the week and you don't hear from them, contact them on the following Monday. Recruiters are juggling many internal and external contacts; a delay in response is more often a conse-

quence of their busy schedule and not a judgment of you as a job candidate. Show them you are interested with diligent follow-up!

No matter how much you grooved with the interview team, and no matter how much you want to work at that specific company, do not stop hustling! You need to keep multi-tasking all of your leads until you officially accept a position.

Sometimes jobs fall through. Internal candidates raise their hand and get selected. Budgets get cut and positions go away. Nothing, I repeat, *nothing* is a done deal until you have an offer letter in your hand.

Do not stop looking and meeting with companies until you have signed an offer letter!

You're so close.

Don't stop bringing that hustle.

Hack #16

Get Paid What You Are Worth

You got the job offer!

Now, don't let excitement get the best of you and say "YES" right on the spot.

I know you'll feel this way, because I've felt the same way and acted on that impulse. I was so darn happy to receive the job offer I couldn't say yes quick enough.

What a mistake!

Hindsight is 20/20, so I know now that saying "yes" without understanding the market value of my position was a misstep that cost me years of playing salary catch-up.

Talking about money makes most people feel uncomfortable.

We women need to get over it.

If we want to get paid what we are worth, we need to look out for ourselves.

Don't expect any lawmakers or human resource departments to make this any easier for you.

It's all up to you to look out for you.

No one else can do this for you.

Unfortunately, I don't have a chart or calculator to make this easy for you. But I do have some helpful thoughts and guidelines to help you figure out how to get what you are worth.

You should understand that your entry salary is a defining decision.

This is a bar you will set and use as a mental measuring stick for the rest of your career.

But more importantly, your salary is a bar you are setting for your new employer. From this day forward, all salary calculations at this company begin with this entry salary figure. Every raise, cost-of-living adjustment, etc. is typically calculated as a percentage of your current salary. You need to set yourself up with the best offer possible to ensure you stack the math in your favor.

You, and only you, are responsible for knowing the value of your seat.

That is an intimidating thought, I know. But, no one will stand up for you better than you.

Get cracking and do the research. There is so much you can learn online! Not just from job boards. Look for places where real people contribute real salary information. **Glassdoor** (glassdoor.com) is a great tool for getting salary data from employees at different companies. Don't just look at what they are making at where you are interviewing; look at the company's competitors! Get a true understanding of what the market will bear for your position.

You need to vet your salary assumptions by looking at a bunch of different sources.

Don't just go with a number you see and like. Salary information on the internet can vary wildly; don't assume the highest number is the one to go with.

Ultimately, you need to hone your salary expectations to a range. Know that you will aim for the higher end, but you need to have a firm understanding of the lower end. That is your "I will accept nothing under this salary" number.

You will only speak of your salary expectations, not your salary history.

Now you know the range you want. It doesn't matter if you are currently making half that amount. DO NOT REVEAL YOUR CURRENT SALARY. If a recruiter has this information, they will base their offer on this number. This is how I got burned early in my career.

Even if they ask you point blank what you are making, reply with, "My salary expectations are aligned with the market value of this role. My research has shown me that the range is $X to $X."

There has been recent legislation in some cities outlawing employers to ask candidates about their current salary. Laws change often; you can research whether this is technically illegal in the city where you live. Legal or illegal, you will not reveal current salary. You will only speak of salary expectations.

It's the recruiter's job to get you at the best rate possible. I know that sounds harsh, but sometimes the truth sucks. If a

company can pay you less for doing the same job, it's a cost savings for them. If they can get you "on sale," they will. Would you pay retail if you were offered a sale price? Of course not. So, why would you expect anyone else to?

A few months into one of my early jobs, I was out at lunch with a handful of my peers. Salary came up; we were all discussing how we thought we should be paid more. One of the loudest complainers blurted out her salary. I nearly died when I heard the number. She was complaining about her salary, which was roughly twenty percent more than I was making! We were doing the same job, only they secured me at a bargain basement price. I felt angry and ashamed.

Don't let this happen to you.

You need to assess the value of the entire job offer package.

Examine the details of medical and health benefits, whether you qualify for overtime pay, vacation days, etc. You may be young and not thinking about health insurance now, but you will if you ever have an unexpected trip to the emergency room or an illness that won't go away. Trust me on that.

An offer is more than a salary number; you must understand and assess the entire offer package to decide. Add up these details to determine the total value of the offer.

You need to judge all the merits and challenges you

expect will come with the job.

When you started this search, you came up with a list of requirements and deal breakers. It's time to pull out the list and make a comparison. Do you feel good about the person who will be your direct manager? How about the work environment? Do you have confidence that there's room for you to grow at the company? Don't lose sight of these factors. They will not come to you in the offer letter, but they are just as important.

You will have limited clout with negotiating an entry-level starting salary.

It's essential to have a range researched and set before you receive the official offer. If you did your homework, and it falls in that range, good work! If you ask for more, keep it within that range. Shoot outside of that range on a counter, and they may rescind. As an entry-level employee, you are as green as it gets in their eyes. Save your hardball negotiations for later in your career, after you've gained great experience and have built a solid professional reputation.

You can get what you are worth.
And when you do, you will feel like a bona fide badass.
Make. It. Happen.

Hack #17:
Be a Graceful Winner

YOU DID IT.

You landed the job.

The offer letter is signed.

You know your start date.

But, before you happy-dance off into the sunset, you have a few loops to close. I know, I know. You want to move on with life; I get it. The good news is nothing I'm about to suggest will take much time or effort.

I am going to ask you to be a graceful winner. A bit of professional courtesy can (and will) go a long way.

Graceful winners never burn a bridge.

Let's say you were working the shittiest job in the history of ever, and you could not wait to quit. I don't care how sucky it is; you should never mic drop and peace out on a job. It is a standard professional courtesy to provide an employer with two weeks' notice. Even a new employer eager for you to start would expect you to provide proper notice to a current

employer. Your new employer will understand. They wouldn't want you to pull that crap on them. Do the right thing and see your job through to a graceful conclusion.

Graceful winners see no reason to go postal in an exit interview or to tell off an old boss or co-worker that drove you insane.

What's the point? Let it go. You're moving on. Ride it out, be helpful for any transition efforts, and be your best until you leave.

It's a small world. You never know who knows whom. You never have to worry about those kinds of shenanigans coming back to haunt you if you take the high road.

Graceful winners are polite and specific with job offers they decline.

You likely talked to a number of recruiters when you accepted your new position. You may have been blessed to have multiple job offers. Be sure to loop back with every contact you were in active talks with to withdraw officially as a candidate. Don't ghost them, even if you were in very early stages of talks.

It's simple. Thank them for the opportunity and their help and let them know you accepted another position. And it doesn't hurt to let them know you would like to stay connected to them. Who knows what positions they may have to talk to you about in the future! However, I caution you to be careful with how you state it; a subtle approach is best. Don't send mixed messages if you mean to decline the offer.

I have an insider tip for you: recruiters are tight with each other.

They move around companies, just like any other person would. They also stay connected and help each other out. So do the math. If you were graceful and professional throughout the process, they would speak of you well. If you pull a jerk move, it can burn you years later, and you won't ever know why the opportunity fell through. Trust me on this. It happens.

Graceful winners express genuine gratitude to everyone who helped their job search efforts.

If you took my advice, you were talking up your job search to many people. Several of them helped you along the way. Some of their help may not have panned out to anything, but they tried, and that's all that matters.

I want you to follow up individually with each person who helped you. You read that right. I want you to follow up with each one separately. Don't mass email or status update on social media and expect that it checked this box. Even if the gesture was small, you should acknowledge it. Also, you have great news—and great news is fun to share! Provide a brief update on the position you took. And most importantly, thank them for the help they provided.

If people go out on a limb for you, it is your duty as a decent human being to thank them. And, oh yeah, remember the last time you did something sweet for someone, and they didn't acknowledge it? It felt crappy, didn't it? How willing would you be to do another favor for that person? Mm-hmm. I don't think I need to draw that conclusion for you.

Be a graceful winner. It will always serve you well.

Hack the System:
How to Kick Ass at Any Job

• • •

Listen up, Real-World Feminists!

You've got the fire; you've got the drive; you've got the skills.

You're ready to start climbing that corporate ladder.

I'm here to help with some practical advice that can help you get further, faster.

But first, I need to share a simple truth.

No one gets promoted by just doing her job.

There are no trophies for participation or ribbons for good attendance.

Doing your job well keeps you employed. It keeps the paychecks coming.

Doing your job well for a prolonged period will not earn you a promotion. Putting in the time won't win you the next level.

Promotions are earned, not given.

If you want to climb to the next level, you will need to do more than just your assigned job.

If you want recognition and reward for your contributions, your performance needs to stand out as stellar.

You will need to hustle and kick some ass.

Kicking ass isn't just about accomplishments and achievements; it's also a state of mind.

It's the attitude you show up with every day.

It's how you partner with other co-workers.

It's about taking what makes you authentically you and branding it as your secret sauce.

It's about ensuring the right people notice your contributions.

No matter your industry or trade, certain guiding principles can help you succeed and stand out from the crowd.

Master these skills and you will be known for kicking ass.

Some of the tools ahead may seem outdated or unfair.

I didn't create the system.

But I will help you hack it.

Hack #1:
Start Great Habits from Day One

You got the part, and today is no dress rehearsal.

It's Day One of your new job.

Time to show up and give it your best effort!

Whether the position is a short-term stepping-stone on your career path or a place you'd be happy to settle in and spend a few years growing professionally, you're here. And you need to make the most of this opportunity.

I'll tell you this. You can position yourself for long-term professional success as early as your first day. With the right habits in place, you'll be able to make a name for yourself in your new role.

You didn't take this job to be mediocre.

Set the tone and stand out from the start.

Simple Success Habit #1: Arrive fifteen minutes earlier than your official start time.

You may be surprised to see such a fundamental idea called out as so important. But a fifteen-minute head start on the

morning can make a world of difference to how you execute the rest of your day.

What will fifteen minutes buy you? It's fifteen minutes of headspace to figure out the plan of attack for your day. You can examine your calendar and make sure you are ready for any scheduled meetings. You can decide what urgent tasks must be completed today and what can wait. You have time to yourself before the madness begins—and it will do wonders for your mindset.

This time hack gives you a jump-start. It's going on the offense, instead of spending all day on your heels.

Let your co-workers stumble or rush in a few minutes late.

You will develop a reputation for being early, calm, and prepared.

Simple Success Habit #2: Dress a little nicer than you think necessary.

Each work environment has a different culture or requirements for professional dress. Even in the most casual offices, I encourage you to dress better than you need to for two reasons.

First, whether it's conscious or unconscious, others will notice.

I know you may be thinking that this seems unfair to be judged on such a superficial thing. This won't be the first hack that makes you bristle or roll your eyes.

Look, it's human nature. Maybe your generation will help change this dynamic over time. But, for now, understand people notice things like dress. Why fight it when you can use

it to your advantage?

Second, and more importantly, dressing well helps you get in the mental zone. To this day, I will take my outfit up a notch on workdays where I know I need to bring my best, such as important presentations or special client meetings.

You don't have to spend tons of money on a whole new wardrobe. Have a few classics, neutral pieces that can be forever mixed and matched. Add in a statement piece or two. Take care of the stuff you own: iron the shirt, clean the boots, and mend the loose button. A little maintenance goes a long way to make you look polished.

Dressing well is a Jedi mind trick.

You will be known as a pulled-together professional.

Simple Success Habit #3: Come hungry for knowledge and connection. Stay that way.

On your first day, human resources will likely have an orientation plotted out for you. It will focus on HR-related concerns, such as company policies and benefits, and it will give you the lay of the land.

The real knowledge comes after the HR orientation. As you meet your new manager and co-workers, they hold the scoop on the way things work. Make it your mission to build relationships with your team. You're about to spend eight hours a day with these people, so get to know them!

Not every workplace or team is great about setting up a new employee for success. Recognize that possibility and be prepared to tackle the problem yourself. It's on you to track down

the information you need to succeed. This is your career; don't wait for others to drop knowledge into your lap. Ask questions! Invite your co-workers to share download materials. Talk to people to understand their roles and work preferences. Figure out how the team works together.

Promise yourself now that you will never, ever stop learning new things about your industry, your company, and your team. Take this as a serious responsibility to yourself and your career. Stay on top of the latest industry news and trends. Keep seeking to learn new skills. Be open to connecting with new people.

The world changes fast. I've seen peers of mine become irrelevant at their jobs because they didn't invest the time in learning and pushing themselves to develop new skills. I'm asking you to make this a habit at the start of your career. It's much more difficult to make it a practice later. Don't become a cautionary tale for others. It's up to you to stay relevant. No one else can or will do that for you.

This simple hack will keep you sharp.

You will be recognized as an intelligent person with a pertinent opinion on industry news or trends.

You've put in a great deal of work to get this opportunity.

Lean in and make the most of it from Day One!

Hack #2:

Build and Tend Your Professional Network

You learned from your job search how powerful human connections could be.

Now that you've landed a job, it's time to build your professional network. If you only grow your connections when you are looking for a favor, you are going about it wrong.

Life changes and people will come and go throughout your career. I try to stay connected to the ones who matter, and you should, too.

Lucky for you, social media provides you with an easy tool to help manage these connections. Before you start sending out **Linkedin** (linkedin.com) invites to all of your new co-workers, understand that networking is not all a numbers game. You should value the quality of your connections over the quantity. For instance, if you are linked to thousands of strangers on LinkedIn, how many do you expect would help you out in a pinch? Hint: very few, if any.

Some people you work with will become valued friends. There may be a time in your life when they are essential to

you. Then they change companies, and you don't see them anymore. Life can be seasonal that way. But you'll always have the power of the time you were connected. These are excellent connections to keep.

Many people will fall into a solid work acquaintance category. You appreciate each other's work, and you get along well, but you don't connect outside of the office. Any relationship based on mutual respect is a connection worth maintaining.

Some people may be close to strangers to you. But you met at a social gathering and had a pleasant, high-quality conversation. They are worth staying in touch with, too.

If you have had a genuine connection or interaction with a person, stay connected to them via LinkedIn. Don't just throw out an invitation and call it a day. If news of their promotion or new position pops up, send them a note. If you read an article that reminds you of something you talked about, share it with them. Keep the connection warm.

Now let's talk about boundaries.

Sure, you hit it off with your new client or co-worker. But, do you really need to send them a Facebook friend request?

The ease and availability of social media make it a double-edged sword. Set a few boundaries for yourself at the start.

If they are just a professional acquaintance, by all means, connect with them on LinkedIn. But, I urge you to keep them off of the social media platforms you use for personal reasons.

Sure, your new cubicle mate is cool. But do they need access to your Saturday night escapades on Snapchat? The answer is probably not.

Remember the advice about considering your own social media posts during your job search? *Now that you're employed, that goes double!* Always be smart about who can see your information and think before you post. Once your content goes live, it's out of your control. Yes, even if you delete it.

You're working hard to build your career. Don't sabotage yourself by posting stupid things on the internet. Please.

You've just started your career, but it's never too early to start making connections with company and industry leaders.

If you haven't met your boss's boss, find an opportunity to introduce yourself. Be ready with that elevator speech and make that interaction work hard for you. You want them to know who you are.

Who are the influential leaders that regularly interact with your team or department? Connect with them. Opportunities to do so are present; you just need to find them.

Peer connections are a breeze to make. Why not challenge yourself to meet those beyond your day-to-day reality? You have nothing to lose by knowing more people at your workplace.

You can build a wonderfully rich and complex web of human connections from the start of your career. Think of it as a garden to tend and set aside a little time each week to maintain it. With this approach, it will be there for you when you need it.

Hack #3:
Truly Understand Your Role

You were hired to do a specific job.

Now, I know it's sometimes tricky for overachievers like us not to strive for the next step soon as we achieve a goal!

But before you seek out special assignments, you need to master the job you are there to do.

Mastering a job takes time.

You need to do everything your company hired you to do well before you look to take on more responsibility. We've gotten used to instant gratification in all aspects of life, but there are no immediate achievements.

Achievements of value take time.

Time to prepare.

Time to practice.

Time to master.

There are no shortcuts.

When you take on a new job, it's crucial for you to understand all the expectations for the role you have taken. Some of these expectations are formally documented and others you

will learn informally over time. Either way, they are the measuring stick for your performance.

You need to know where the bar is set if you're to jump over it.

There are a few ways to go about understanding the formal expectations for your role.

1. Your job description

Hopefully, you procured a copy of your official job description as part of the recruitment process. If not, secure one from human resources.

Read it over and digest the content. Is there anything in the job description that is unclear or needs further clarification? If so, talk it through with your direct manager, not human resources. You will gain better nuances to the significance of the words by discussing them with your manager. HR can only weigh in on the words on the page. They are the keeper of everyone's official job descriptions; they can't offer you counsel beyond generic advice.

Generic advice isn't good enough for an ambitious woman like you.

Discuss it with your boss.

2. The thirty/sixty/ninety-day check-in

Some companies are better than others with formalizing an orientation process for new employees, including helpful mechanisms for early feedback on your performance. And some employers push you off into the deep end of the pool to

see if you can swim.

And, just as no two human beings are the same, neither are any two direct managers. In your career, you will find that some of them are natural mentors and give you coaching and feedback every step of the way. Others will avoid an uncomfortable conversation until it reaches a point of no return.

In any case, I recommend you look to gain early feedback on your performance. If you need to make a tweak or change, you want to find it as early as possible. Trust me on this.

If your company has no formal process for getting this feedback, suggest milestones to your manager directly. I recommend you stick to the thirty-day, sixty-day, and ninety-day marks. Although bosses are different, most of them will happily agree to this request because they need you to succeed.

3. Your department guidelines

The department you work in likely has documented annual goals, guiding principles, or recent meeting materials. Find them. Ask for them. Familiarize yourself with them. Part of understanding the role you do is seeing how it connects to the larger team.

How does the team define what's great?

What goals is the department on the hook to achieve this year?

Are there hot topics of concern or areas of special focus?

Remember, you were hired to make a difference for the greater good. Understand how you can positively impact the team at large.

4. Your company's values

All companies have a point of view on what they are striving for and the values they expect all employees to exemplify.

Larger, more established, companies will have official statements on their mission and core values. You were judged through these lenses as part of the hiring process. Make sure you understand them, as your performance will be viewed through this lens, too.

Small, independent, and start-up shops may not have a formal point of view on company values. But they exist, and they expect their employees to live by them, even if they haven't written them down. For instance, in these environments, they may expect you to be entrepreneurial in spirit and a flexible problem-solver.

What values stand out?

What traits do successful employees at the company share?

Understand your company's values. They are a measuring stick by which all employees are judged.

Accept the informal expectations for your role, too.

As a team member, you'll have unwritten roles. So will your colleagues. Pay attention to the human dynamics when in a group setting. Note how certain people work with other people. If you tune in to the fine points of human dynamics and emotional intelligence, you may discover that you have been brought in to play a role no one would write in the job description.

Maybe there's a key player who you can tell gets on your boss's nerves. Embrace your role as a buffer; it's an easy way

to gain your boss's trust. Or perhaps you discover that you can get two people who don't get along to deliver results. Don't be annoyed; feel empowered by the magic you bring to the table. Other people are noticing.

Get comfortable having open conversations about how you can contribute at a deeper level. Do things like asking your boss, "Can anything I can do to make your life easier today?" when you are having a slow day. Don't be scared to ask this question; few bosses in the world wouldn't appreciate it.

Get a real understanding of your role and how it connects to the big picture.

The better you understand, the better you can shine.

Hack #4:

Turn Your Boss into Your Best Advocate

You are already working for a person who can help make or break your success in your new job.

Yep, that's right. It's your boss.

One of the most important relationships you will have at your workplace is your direct manager.

Think of them as more than just your boss.

A good manager is also a good mentor.

A great manager can be your best advocate and sponsor, helping to showcase your talents and contributions to a greater audience.

Of course, there's also the plain reality that your boss has direct power over your ability to be promoted and future salary raises and adjustments.

A relationship this integral to your career path must be nurtured.

Strive to build a relationship that goes beyond status updates on your job and annual reviews.

Do your part to foster a relationship of mutual respect and open communication.

Be relentless in understanding how your boss is wired and what's important to her.

Why, you ask?

It is how you transform your boss from a mere supervisor of your work into a forceful advocate for you and your career.

How, you ask?

To begin, you will need to think beyond your job description and current assignments. Apply the following success strategies and you will become one of your manager's most valued employees.

Success Strategy #1: Help your boss achieve her goals.

First, to understand what's important to your boss, you need to understand what goals your boss has been tasked with achieving.

Every employee at every company needs to demonstrate regular value. The most straightforward way that a company can judge an employee's contributions is through established goals. These goals are typically set annually and are measurable via mathematical metrics or softer measures such as peer feedback.

Your boss is on the hook for measurable goals. Do you know what they are? If not, find out. They could hold keys to your career success.

Obviously, you should not be so direct to ask for a copy of their goals. Don't be an ass. There are other ways to get at that information.

For instance, let's say your manager kicks off the year with a

department meeting, where she sets out a set of annual goals for the department at large. *Ding, ding, ding! You just found out what your boss is on the hook for.* She's not making up departmental goals for the hell of it; she's using them to carry out the broader mission assigned to her.

There's another way to go about getting this information. As part of a formal or informal career discussion of your own, you could ask, "Are there any company goals or initiatives where I can help you move the needle? How can I better support you?" Smart bosses will take that opportunity in a heartbeat.

Simply put, if there weren't ways you could help your boss achieve her goals, she wouldn't have hired you. Help support your manager's efforts. You'll gain substantial professional experience, make a mark on the company, and earn her trust.

Success Strategy #2: Respect your boss's work style.

Another winning strategy is to get a sense of your manager's work style and adjust yours accordingly.

I'm not telling you to be a different person. But I want you to be aware of underlying human dynamics and harness this power to your advantage.

Everyone works differently. Some managers encourage random drop-in questions. Others prefer that you email quick questions. Some bosses are early morning risers; others are night owls.

Humans are different. Duh!

Don't lose sight of the fact that your boss is a human with her own preferences and work style, too. Understand your

manager's preferences and quirks and make adjustments to how you interact and work with her.

If you see that she looks annoyed when you ask her a question first thing in the morning, don't bother her first thing in the morning.

If she expects you to bring a written agenda to every meeting, then do it.

C'mon. Let's use basic common sense here. Tap into that emotional intelligence God gave you.

Master this strategy, and you'll go from a good employee to one of her favorite employees.

Success Strategy #3: Find ways to make your boss's life easier.

Don't misunderstand me. I don't want you to become a gopher.

Do you want to know the best way to make her life easier?

Stop waiting for her to tell you what to do next!

There is a simple litmus to set good employees apart from the great. Good employees do what they are asked to do well. But great employees take it up a notch and also anticipate the next step and offer to take it on.

Proactivity is a compelling quality. I can tell you from my experience that once you put yourself out there, it gets easier to do. Just as pumping iron will build muscle strength, your capacity to speak up and willingness to volunteer will develop the more you flex it.

Start small by looking for win-win opportunities. Perhaps there's a weekly meeting where your boss has asked you to take

detailed notes on that she'll distribute later via email. Once she trusts you are doing this well, you can make an offer to circulate them to the team directly. Chances are she will be glad to take you up on it. You took a task off her plate and gained a new responsibility. Win-win.

Every workplace is different, so you have endless possibilities when looking for a chance to flex your proactive muscles. If you can take the next step off her plate, offer to do it. Simple, right?

Frankly, there will be times that your offer to do more gets declined. Let's say your boss struggles with delegating. Perhaps she needs more time to trust that you have it covered, or she may prefer doing the task herself. Understand this: it doesn't matter. You win points with them by simply making the offer. Don't let a "no" discourage you; keep being proactive.

The employees who get noticed do more than what they get asked to do. They expect what's next and offer to do it.

Success Strategy #4: Keep your boss in a professional zone.

You can become friends with your boss, but you always need to keep your relationship in a professional zone.

Some bosses we love so much that they become real friends. That's a wonderful thing!

But, never, *never* lose sight that she is your boss with direct power over your employment.

What do I mean by that? Well, you need to set boundaries. You need to apply a filter to what you share with her.

I will break down specific examples, based on real-life-inspired scenarios.

- Yes, you can have an after-work cocktail with your boss. But my advice is to never have more than two drinks with her. If your lips get loose once that second drink kicks in, then it's time to part ways when happy hour ends. You have drinking buddies; your boss shouldn't be one of them.
- Yes, you can talk about family. But, as a general rule, your boss should never learn things you wouldn't want posted on the internet for others to read. Be respectful of your family and keep any dirt to yourself.
- Yes, you can talk about your boy/girlfriend. She can know that he/she exists and that you had a nice weekend trip to the beach. But do not over-share. Spilling your guts about your love life to your boss is not a smart business move.
- Yes, you can connect on social media. But you need to limit their access to your private life. If you are friends on Facebook, categorize them as an acquaintance; do not give them full access to your feed; give them an edited version. And for God's sake, never add them on Snapchat. I don't care how hip your boss thinks she is. I don't care if your boss is your age. Don't do it. If you feel pressured to add her, block her from your story. You can occasionally unblock it and toss her an innocuous item such as drinking a latte at your favorite

coffee shop or celebrating your mother's birthday so she doesn't realize you blocked her.

Your manager has a lot of direct power over your career path. Be smart and strategic in this relationship, and you can harness that power for the good of your career.

Hack #5:

Don't Make Assumptions. Ever.

You want to become someone who is known for over-delivering on every assignment.

You can make this happen.

It's not all about working hard.

It's about working smart.

I'll explain.

Let me start with a quick trip down memory lane.

I learned a profound lesson from my seventh-grade English teacher. It had nothing to do with memorizing a soliloquy from Macbeth or diagramming sentences.

I don't recall the context of how it came up. Perhaps it was a vocabulary lesson. Perhaps she was teaching us a fine point of deductive reasoning.

She had the word "assume" written on the board. "You know what happens when you assume?" she asked the class.

She waited a beat. She had a folder in her hand. "You make an…" she paused and blocked the last three letters of the word with the folder. The room of twelve-year-olds collectively

gasped. She continued, "Out of you and me." She moved the folder to emphasize the words as she talked.

It was 1983. This was scandalous shit.

At the time, I didn't know it was a cliché. It was the first time I had ever heard the expression, and I considered it the gospel according to Mrs. Borocci.

It turns out it's a lesson that will benefit you as you navigate your professional career.

I will state it for you plainly: **When it comes to your professional assignments, don't make assumptions.**

Assumptions in the workplace can be dangerous things. Making incorrect ones can cause you to under-deliver or show up with a finished product that completely misses the mark.

Don't take any assignment at face value. Always make sure you understand of all aspects of the project.

As a general rule, you need to have a clear understanding of the classic five W's. You need real, verified answers, not just what you think the answers are.

Remember what happens when you make assumptions.

The five W's are the Who, What, Where, When and Why:

1. Who is the audience for your assignment? **Who** are you expected to work with?

- Will the final deliverable be shared internally or externally?
- How widely will it be shared? With just your boss?

The department? The company?

What teammates or departments are you expected to partner with?

- Are there stakeholders who should weigh in before your delivery date? Who are they?

2. What is the specific deliverable?

- Do you have a firm understanding of all the parts you are expected to include?
- Are you on the hook for a preliminary draft or a cleaned-up final version?
- Are there elements of the assignment that must be delivered by other parties? What are they and what state will the pieces be in?
- Which format are you expected to use?

3. Where will the deliverable be used?

- Is your assignment a piece of a larger project? Is it a stand-alone item?
- Where will your work be shared? Via email? In a small meeting? In a large presentation?
- What is the context that your work will be framed with?

4. When is your assignment due?

- Do you have a clear deadline?

- Do you have an exact time to hit as part of the deadline? The world moves fast. There is a big difference between first thing in the morning and end of day.
- Are there interim milestones you are expected to hit before the final due date? For example, if you are creating a report for your boss, do they want to see an in-progress draft? Is so, when?

5. Why are you being asked to take on this assignment?

- Why is this assignment important? Understand how it connects to a bigger picture.
- Why are you being asked to take it on? Do you have a clear grasp on how you connect to the bigger picture?

If anything about an assignment is unclear, you absolutely have to ask questions. Sometimes it feels awkward, I know. But, it will be far more awkward if you show up with an assignment that misses the mark.

When should you ask questions? Ideally, you'll want to get your questions out when you agree to take the assignment. But, if you start on the assignment and later discover you have questions, my advice is to get answers as soon as the questions come up. Sometimes a simple email exchange or brief hallway conversation can save you from disaster.

Keep in mind that follow-up questions need to be directed to the correct source. It may feel easier to poke your head over the cubicle and ask the person next to you a question. But do

they really know the correct answer? Or are they making an assumption? Others can unwittingly set you up for a fall. Get answers from the right stakeholders.

This all may sound like common sense, and frankly it is exactly that. However, it's sometimes easy to overlook the basics. You get really busy; you're juggling ten different projects; you have to leave the office today by five p.m. to get to a doctor's appointment… and just this time you think that it's easier to make assumptions then track down requirements. Next thing you know, you made one small incorrect assumption, and now you have the unintended consequence of a disappointed boss and maybe even a public failure.

Don't get burned by a bad assumption.

Fully understand your assignment.

Every damn time.

Hack #6:

Be a Person Who Keeps Her Word

You are building a professional reputation every single day.

Whether you realize it or not.

My best advice on this topic comes straight from my own playbook.

I take great pride in honoring my commitments. In all aspects of my life, personal or professional, people know they can trust me with a promise. If I say I will get it done, I get it done.

If you want people to trust you, you will need to be a person who keeps her word.

No matter what your role.

No matter what your industry.

Do what you say you will.

This concept is easy to say, but difficult to master. Allow me to break down some key strategies to help you keep your word.

Success Strategy #1: Be smart and deliberate about your commitments.

To honor your commitments, you have to be smart about what you agree to do.

If you know you can't do a task well, don't promise to do it.

If you are already over-extended, don't take another project on until you catch up.

If you are busy but still want to take on a new assignment, make sure you can re-prioritize what's on your plate before you say "yes."

Success Strategy #2: Under-promise and over-deliver, with shrewd intent.

Management 101 books and articles will tell you to under-promise and over-deliver.

It's good advice on the surface, but you don't take these words at face value.

People will see right through it if you set a low bar. You won't fool anyone with that move.

When you commit to a deadline, think about under-promising and over-delivering. For instance, if you think you can get it done by the end of day Friday, pad the timeline a little and say you can have it ready by Monday at noon. It's an insurance policy against unexpected delays. Drive toward the first deadline you set for yourself; it will look great if you can deliver early. But you have a cushion now, just in case.

Success Strategy #3: Define contingencies before you begin.

Next, safeguard your commitments by defining any known contingencies before you start working.

What do I mean by this?

Well, it shouldn't be a problem for you to honor your commitments. But what if your deadlines are contingent on someone else meeting theirs?

It's easy. Set these expectations at the very start.

Say you are on the hook to deliver a report, but you need another person to complete and hand off research to you to finish it. When you commit to a deadline, you need to add in an expectation-setting caveat. It could sound like, "Assuming I have the comprehensive research in my hands by the end of this week, I can have the report finalized for you by close of business on Wednesday."

It's not enough to define the contingency; you need to manage it.

Be proactive about following up with the other party and keeping others in the information loop. To build off the earlier example, you should not only follow up with the team responsible for getting you the research; provide updates to whoever is expecting your report. Don't just update others if a problem arises; tell them when you are on track, too.

Success Strategy #4: Be proactive about status updates.

Don't forget to keep others in the loop along the way.

You don't have to be obnoxious about it, but keep people informed. If you are working on a special project for your boss, proactively give status updates. It's always best to give this information before they ask for it.

Again, keep playing offense.

If you have to be asked for an update, you are playing defense.

Trust me on this, most bosses or co-workers assume the worst if they don't hear from you. It's just human nature; we're wired this way. Get and stay in front of this negative bias and keep people updated on progress. Your proactive communication will build confidence in your ability to deliver.

Success Strategy #5: Build in time for feedback if you need it.

This is important if you have taken on a more complex project.

When you have opportunities to take on a project that falls outside your comfort zone, consider it a best practice to build in time to get feedback or direction along the way.

Imagine if you go at it alone and, despite your best efforts, show up at the end with a deliverable that misses the mark. Ugh, what a bummer. Your best intentions just backfired on you.

A good boss will know when you are taking on a stretch assignment. A good boss will be open to giving you coaching and guidance along the way. Trust me on this. Don't be afraid to ask for the opportunity to get feedback.

Success Strategy #6: Report bad news early.

Sometimes, shit happens.

When it does, remember that the Godfather insists on hearing bad news immediately.

Yes, I slipped in a Mafioso pop culture reference BECAUSE NO ONE WANTS BAD NEWS LATE.

If you have run into an issue and realize you can't meet a commitment, you need to deliver that news as soon as possible. Do not show up at the deadline with only part of what you committed to.

If you come up short on a commitment, it won't matter what excuses you bring to the table.

Even if you hit valid obstacles, it will not matter.

You committed.

You should not have waited until the deadline to let them know you would be late.

It doesn't matter if the entire world conspired against you.

No one is to blame at that point but you.

You committed to delivering.

It was your responsibility to deliver.

As a boss who actively delegates special projects and assignments to others every single day, I cannot stress this point enough. When an employee shows up late with excuses, she damages my trust in her. I am not alone in thinking this way. Your boss will feel the same way.

So, be up front about the challenges you run into as soon as you learn what you are up against.

Bring your ideas for how you could mitigate the problem.

Speaking for the bosses of the world, we want you to succeed. Speak up and do more than inform your boss. Use the time to get their feedback, enlist their help to remove barriers, and get coaching to get back on track.

Success Strategy #7: Just effing do it.

Maybe it's harder than you expected.

Other things came up that drained your free time.

The team you are working with isn't as focused as you are.

DO IT ANYWAY.

Your word and reputation are at stake.

Let nothing distract or derail you from getting it done.

There are two types of people in this world: those who keep their word and those who don't.

Who do you want to be?

Hack #7:

Be a Person Others Want to Work With

You know that it's important to build a relationship with your boss.

Want to know which other professional relationships are essential?

Every single one of them.

Yeah, it was a trick question.

Listen, impressing your boss or the management team with your performance isn't enough to be successful in your workplace.

You will need to be a person other people want to work with.

If you can deliver results, but you get a reputation for not playing well with others, it will be a problem.

Your bad behaviors will taint your successes.

How you treat other people matters.

Let's be real about this. You will not be friends with everyone. And there will be others you flat-out can't stand. But, no matter what their position, no matter their quirks, you need to treat everyone professionally.

People talk. Do you want them spreading good things or bad things about your work and work style? Reputations don't stay within the four walls of your workplace. Trust me; word gets around. You want people singing your praises, not giving side-eye and dishing dirt when your name comes up.

So, how do you gain the respect of your co-workers? Here are some simple success strategies.

Success Strategy #1: Try your best to take the high road.

I'll admit being the bigger person is WAY easier said than done.

There will be people who will do you dirty and times you get screwed. But taking the low road will never benefit your reputation or career path. Keep your head in the game and don't let others bring you down to their level.

I'm not telling you to eat shit, but you need to be smart about getting egged into emotional behavior that will only reflect poorly on you.

Let's say you get an email that sets you off. Anger explodes in your chest; you bang out a response.

I BEG OF YOU: DO NOT HIT SEND.

Never, ever email in anger. If you need to get the words out, go ahead and type them. But save it as a draft and do not send. Walk away! Sleep on it. I can tell you from personal experience that waiting twenty-four hours makes a world of difference in choosing how best to respond. Give yourself this breathing room.

A wise colleague once said, "Not all emails need an answer."

You will likely find it's best not to respond, at least not electronically.

Here's the thing with email. Sure, it gives you an instant outlet to respond. But it lives on. Like, forever. A permanent (and easily forwarded) record of the time you lost your shit in an email. Your boss might read it... or human resources might. It happens. I've been on the receiving end of these forwarded email chains plenty of times.

It's easy to get caught up in rounds of an email smackdown. Wouldn't you rather stay above the fray?

You should strive to be constructive in how you manage conflict. Conflict will happen in the workplace; healthy conflict is necessary to doing good business. We will not agree with each other all the time. Disagreements are fine; we just need to be adults.

You will know when someone is triggering you. You will feel it. Don't let them. Do your best to keep the conversation constructive.

Be known for taking the high road.

Success Strategy #2: Don't be a gossip.

I know that workplace gossip can be fun. Especially when it's juicy news about the latest office hook-up, drunken incident at the holiday party, or the scoop on your boss's new boss. I get it.

But gossip is low-vibration energy to put out into the universe. Those who help dirty news spread get tainted themselves, especially when they spread information told to them in confidence.

People figure out who the gossips are. Do you think it's good for your professional reputation to wear this label? Spoiler alert: it's not.

Be known for speaking facts, not rumors.

Success Strategy #3: Don't be a complainer.

Companies and workplaces are like living beings. There will be ups and downs. Sometimes business is great and sometimes it's not. Department reorganizations happen. Bosses leave the company.

Even in most stressful times, I encourage you not to be one of the people making it worse by complaining all the time.

Complaining doesn't look pretty on anyone.

If complainers surround you, then find ways to disengage. Just walk away. Joining in with the complainers won't make you feel better. It will make you feel worse. Much worse. I know this from first-hand experience.

You are not powerless, even if you feel you are at the bottom of the totem pole. Make your situation better or search for another opportunity.

Don't just bitch about it; take action.

It's as simple as that.

Be known as a productive problem-solver, not a complainer.

Success Strategy #4: Don't be a dick.

You heard me.

Don't be a dick.

Even as retaliation for a dick move.

Even if you are dealing with the King of the Dicks.

There is never a justifiable reason to be a dick.

No one wants to work with a dick.

Success Strategy #5: Strive to be a good human. Always.

Everyone has bad days.

Everyone has people she doesn't like.

But these are not good enough reasons to treat anyone poorly. Be respectful and pleasant to everyone. Smile and say hello to the security desk guys. Ask the cleaning staff about their weekend. Genuinely thank the barista who knows your order.

Acknowledge and see people. Contribute to the world in this way. It matters.

Be known for being a nice person.

These things add up and do more than help you build a stellar professional reputation. There are personal benefits. If you approach others according to these principles, others will be more willing to do the same with you. Your workplace (and the world) will be a better place.

Good energy begets good energy.

This is Karma 101, people.

Be a person that others want to work with and overall you will be a happier person.

Hack #8:

Make the Most of Constructive Feedback

You thought you killed it in that client meeting, but then your boss takes you aside and asks you that dreaded question: "Can I give you a little feedback?"

Ugh.

Chances are, you will not enjoy hearing what they have to say next.

But it's like eating vegetables when you were a kid. You knew they were good for you, but that doesn't mean you liked the taste of them.

Feedback is a bit like broccoli that way.

I won't lie, sometimes getting feedback on your performance sucks. Even to this day, it stings me to hear "constructive criticism."

But, over the years, I've learned to embrace feedback. When I'm working with others I admire and respect, I proactively ask them for it. I see it as free advice. Why not pick their brain and receive it?

When a manager, mentor, or peer gives you feedback, it's a gift. Seriously. They are speaking up because they want to

help you be better at what you do. No one likes uncomfortable conversations, and giving constructive feedback can often be uncomfortable. Think about it. They are taking on an awkward conversation to help you. If they didn't care, they wouldn't bother.

When someone offers you feedback, listen.

Even if it stings.

Thank her for her perspective.

If you feel overwhelmed or on the verge of tears, then tell her that you need time to process her feedback. Then get the hell out of the situation as quickly as you can. You don't want to be tarred with the "emotional woman" brush.

Good or bad, I find that it's helpful to give yourself twenty-four to forty-eight hours of digestion time. Because there's usually truth in others' feedback. You may not wholeheartedly agree, but work to understand their perspective. If you find you need further clarification, ask follow-up questions. Ask them how they might have handled the situation.

If you are not sure how your boss or team feels about your performance, ask them for feedback. There's no need to wait for an annual review to have the conversation. You don't have to make a big deal of it. Ask about how you handled a specific meeting or deliverable. See if they have any feedback before you start your next project.

The best bosses in my career have been treasured mentors. They helped me build confidence so I could find my leadership style and voice. They were real role models.

And some of my bosses were jerks. They helped me under-

stand the boss I never wanted to be.

What I mean to say is, everyone's feedback is not equal.

Some feedback will stem from personal biases.

Some feedback will come from people you don't respect.

Some will teach you more about the giver than about you as the receiver.

Some feedback will make you realize that you don't belong in that workplace.

On the other hand, some feedback will help you grow toward perfection.

Some feedback will inspire you to become a better person.

Some feedback will be specific and prescriptive.

Some feedback may take you years to digest and understand.

Some feedback will burn into your soul and make you forever grateful for having received it.

Be open to feedback.

Listen to it.

Process it.

Then, only you can decide what to do with it.

Hack #9:

Be Bravely Ambitious

You have that special spark.

The spark that shows your boss that you love what you are doing and are driven to take on more responsibility.

It's an undeniable, beautiful spark.

I want you to boldly and fearlessly show that ambitious spark.

To everyone.

To the universe.

Some people think "ambition" is a dirty word.

I'm here to tell you healthy ambition is a gorgeous sight to behold.

Healthy ambition is grounded in humility. It doesn't shy away from hard work; it seeks it out. It holds an unquenchable thirst for learning, about the industry, the craft, the company, the team. It contains a bit of fear of taking on a new responsibility but bravely faces it head on anyway.

Healthy ambition will result in rewards: new challenges, new positions, raises, and promotions. Trust the process. Trust the universe.

On the flip side, unhealthy ambition is an ugly, ugly thing.

It's grounded in entitlement. It thinks time in the role makes a person worthy of more. It's thick with insecurity and negativity. At its core is a belief that doing a job qualifies a person for reward. It does not hide its bitterness over lack of recognition.

Unhealthy ambition comes from a powerless place, a *why-me* mentality. It craves more but does not acknowledge that it all starts within.

Unhealthy ambition has tarnished the meaning of the word "ambition."

I ask you to reclaim the word "ambition."

Face the world with a healthy, sparkling dose of it.

Come from a *why-not-me* mentality.

You can make a difference to your team.

To your workplace.

To your neighborhood.

The world needs you to bring it.

We're counting on it.

Hack #10:
Win with Extra Credit

As a student, you went after every opportunity to earn extra credit.

Summer book reports, turning in term papers early, additional lab assignments.

Even though you were getting A's anyway, you liked having the extra points in your back pocket. Just in case.

There are ways to earn extra credit in the workplace, too.

Extra credit opportunities naturally come with extra work. As a consequence, you will need to put in extra time.

Extra credit opportunities also come with increased visibility. Extra credit will get you noticed.

Before you seek or take on any extra credit assignments, you must adhere to a critical pre-requisite: perform well at the job you were hired to do. If you don't consistently receive great feedback from your boss and your peers, apply your focus and energy to doing the job you were hired to do well. I cannot emphasize that enough. Extra credit will backfire on you if you suck at your job.

If you successfully meet the pre-requisite and are ready for

some next-level visibility, it's time to look for an extra credit opportunity.

Every workplace and industry is different. Therefore, opportunities for extra credit will come in many shapes and sizes. Sometimes, there will be an open call for volunteers. Other times, you notice a problem that can be solved. There are always issues and processes that require attention and, usually, there are not enough people who want to make a difference.

You can't raise your hand for everything. How will you know that an opportunity is right for you? Here are some guiding principles to help you win at extra credit opportunities.

Success Strategy #1: Get involved in a cause you care about.

This does not mean you have to have an undying passion for this cause. It could be a simple issue that just so happens to drive you crazy. Fixing it would make you feel good.

At the end of the day, if you are indifferent about the issue that needs attention, you won't bring your best. Look for a better opportunity. People can tell when you have a real passion; that's the quality you want to demonstrate.

Success Strategy #2: Join a committee or team that's already making a difference.

Want to connect with other people who give a damn? Volunteer for a committee or task force team. This is a great way to get your feet wet with extra credit opportunities. The bonus is that you get to work with people who likely fall outside of your

direct team. Workplaces tend to be insular, and it can be difficult to get to know people outside your department or group.

Committees can be an excellent way to experiment with extra credit.

Success Strategy #3: Find a way to contribute as an individual.

Anyone can join a committee.

When you are ready to level up your extra credit game, speak up and take on a responsibility. Start with a small suggestion if you are a little nervous. Small wins will help you build confidence and get ready to take on more substantial items.

Although it's always good to be known as a team player, you need to find ways to stand out for your individual contributions.

Success Strategy #4: If you have a great idea about how you can better contribute, speak up!

If you see an issue that is causing a business problem, and you have an opinion about how it can be addressed and how you can make an impact, you simply need to speak up.

You can't count on other people to connect the dots on your behalf.

You shouldn't wait to be asked for your opinion on the matter.

Show your boss that you are thinking big and present your case.

Prepare your thoughts, put together a short presentation, and ask for an opportunity to share your idea. Put effort into your thoughts; don't just wing it in a casual touch-base. Do

some research, write out your idea, ask for the time to present, schedule the meeting, and deliver your case with conviction.

Win or lose, you win. You just showed up to your boss as someone who cares enough to put together a well-considered idea for how you can make a difference to the company. This is how you get noticed as a top performer.

Success Strategy #5: Follow through like your reputation counts on it. Because it does.

You put yourself out there.

Now you need to put in the extra time and effort to make it happen.

Do not volunteer to take on additional work if you cannot deliver.

That will be counter-productive to what you are trying to achieve.

We're talking about next-level gains here. If you want to stand out from the pack, you need to find ways to contribute beyond your job description. It's a difficult yet simple way to get noticed.

You've got the fire.

You've got the ideas.

Now, it's time to speak up and show up like the badass Real-World Feminist you are.

Hack #11:

Make Sure Your Badass Work Is Noticed

You know you are kicking ass.

But, do others know?

If you are kicking ass but no one knows it, you are not kicking ass.

Let me put it a different way for clarification and emphasis.

If you are kicking ass, but the RIGHT people don't know it, you are not kicking ass.

Self-promotion feels like a dirty word. Done obnoxiously, it sounds skeevy—used car salesmen come to mind. Done gracefully, it ensures you are on the radar screens of influential people.

Self-promotion is one part science and two parts art. It combines formally documenting your wins and informal humblebrags. It's information you share yourself and what other people say about you. And, as with any art, it gets easier to do with practice and time.

Let's examine the elements of successful self-promotion.

Success Strategy #1: Utilize the informal humblebrag.

First, one of the most influential tools at your disposal is the easiest to carry out. There are many ways to approach the informal humblebrag. But, the key is it has to come from a modest place. If you share with a #humblebrag tone, it taints the victory.

Tone is important. Position your contribution in the context of the business or the team. This way, it reads as a status update on your progress toward a more significant mission, as opposed to a "check out the great thing I did" flaunt.

The easiest way to ensure your tone hits the mark is to approach your update from a "we" point of view, not an "I" point of view.

Suppose you just solved a team problem or accomplished a large action item. Cc'ing your boss on that victory email is tempting, but I recommend you don't. It's like dancing in the end zone after a touchdown, and not in the fun way. Don't send the wrong message.

My favorite way to humblebrag is a little thing I call the "FYI Email." Take the email chain that shows your win and forward it to your boss with context. For example, if you received a lovely note from a client expressing gratitude, forward it to your boss with a note that says something like, "FYI, wanted to share the below client note. I'm really proud of the way the team delivered on this project!"

Or maybe you want your boss to be aware of some badass accomplishments but have no specific request for them to take

action. Take an email that shows the latest status and forward
with a note stating "FYI, no action required." Add a simple
statement that gives proper context, like "Just keeping you in
the loop on this project—we made great progress this week!"

That's it. It's as simple as making them aware of your
contribution.

You can deliver the update in person, too. The drive-by
"heads up" office visit is my go-to. State the problem and how
you solved it. Make it clear that you've handled it, but you
wanted to inform them in case it came up. Bosses love to be
up to date, especially if they don't have to clean up a mess. If
you made their life more convenient, bring it to their attention.

The other thing about the humblebrag is to use it wisely.
Your boss doesn't need to know everything you have done or
solved. That's your job. It's why they hired you.

But you know when you made an impact, so don't be timid
about bringing it up. The humblebrag is for those small wins.

Success Strategy #2: Use formal status updates for bigger initiatives.

You should put more effort into sharing your larger-scale
accomplishments. Be sure to keep your boss abreast of your
big wins.

If you are working on a large-scale initiative that will take
time, use official channels to share your progress and document
the journey. For instance, is there a status report you can share
with your manager or other key stakeholders? If not, consider
starting one. Pick a format and frequency that will make it easy

for them to digest. (No one wants to read a wordy document every week.) It can be as simple as an email, but its format and timing should be consistent.

Once you begin, you need to deliver this report consistently—keep that in mind when determining how you want to provide the updates. If you miss a weekly update because you're bogged down with work, it's going to look like you're not in control of the project. As a general rule, people will assume the worst in the absence of information. If your regular report disappears, they will most likely think you are dropping the ball. Be honest with yourself before you commit to this update; you must stand by your commitment, or risk it backfiring on you.

You should also share the output of these larger-scale wins. When the report is complete, share a copy. When the work is finished, be sure they see it. If you can share it electronically, do it—that way your boss can forward it to other stakeholders, like their boss or other company leaders.

Make sure the right people are aware of the great work you are accomplishing.

Success Strategy #3: Apply a little polish to everything you do.

Think about the last time you splurged on a small item, like an expensive lipstick or piece of jewelry.

It came in a pretty box, wrapped in beautiful tissue paper, and the sales clerk walked around the counter to hand you that well-made shopping bag.

You felt like you bought something special, something

luxurious.

Sure, it was just a lipstick. And, okay, maybe the quality of the product itself was better than one you could have gotten at the drug store. And, yeah, the lipstick will still get beat up in the bottom of your purse, just like the drugstore versions do. But at that moment, it felt more significant—good, even—all because the store made that everyday item look special.

You can apply this same logic to your daily work style. A little polish and packaging can go a long way.

Consider how you can bring a little extra polish and sizzle to everyday work items. For example:

- Don't just bring notes to your weekly one-on-one meeting with your boss. Type up an outline, email it one day in advance, and have a copy for her.
- Make sure you include an agenda for every meeting request and bring printed copies to the meeting.
- Be a notorious editor of your emails before you hit send. Every email should give easy-to-digest insight into what you need from every recipient. **Bolding the most important sentences is an effective tactic.** Is the email meant to keep them informed, answer a question, or drive an action? Be clear and deliberate with your words.
- Always open an email with a proper greeting and end it with a proper salutation. Starting an email without a "Hi So-and-So" or "Good morning, Team" is coarse. It's like walking into a store and saying, "I want to buy this" to the clerk without saying "hello" first. Also,

don't get too cutesy with your sign-off. Don't include inspirational quotes or strange fonts. A simple "Thank you" or "Best" with your name works just fine.

• If you have an idea you want to run by your boss or your team, put together a short presentation. A PowerPoint document or Keynote presentation projects as more together than a Word document. It's the roughly the same word processing effort but looks much more polished.

• Keep your workspace neat. Even if the system makes sense to you, the stacks of paper and loose files will scream, "I'm a hot mess!"

The possibilities are endless. A little extra attention to how you present yourself in everyday matters will help you build a kick-ass reputation. People will notice.

Success Strategy #4: Seek opportunities to increase your visibility.

Even in small companies, people become insular. You have the team you work with day after day, and most people keep their interactions within these boundaries.

You've been kicking ass and doing the right things to build your reputation with your boss and team. Why not push this boundary and let others in on the secret of your badassery?

Find ways to connect with people outside of the everyday grind.

Be part of making a difference at your company. A special task force is looking for volunteers? Raise your hand and contribute!

Volunteer for committees focused on issues you care about or pique your interest. The subject doesn't need to center on work. Perhaps someone in another department is organizing a team to take part in a charity walk for a cause meaningful to you. Join the club!

Look for industry-related events or special interest groups within your company. A group of people is gathering to go to an industry happy hour; why not go with them?

You notice a small book club that meets every month in the cafeteria. If it sounds interesting to you, why not ask if you could join?

Be known as a hand-raiser.

You'll be happier.

You will also build a network and make connections outside your direct team. This will help you develop your reputation beyond the small circle of people you see every day.

Success Strategy #5: Do the heavy lifting in formal performance reviews.

I've talked about the importance of being open to receiving feedback. But formal reviews give you more than feedback; they are an opportunity to gain a written record of your badassery, along with a documented roadmap for your next promotion. So you need to take the annual review process very seriously.

Do not be passive about your formal reviews.

Don't wait for the invite.

Don't just wait to see what your boss has to say.

Hop in the driver's seat and do some heavy lifting on your own behalf.

Your company will likely ask you to prepare a self-evaluation as part of the process. Whether or not they expect this, you should do your homework and organize your thoughts on the matter. Although the first draft will be a self-journaling exercise, you should edit and polish this document to present to your boss as part of the discussion. That's right; you should give this document to your manager.

As you craft your self-assessment, consider your answers to the following questions:

- What accomplishments make you proud?
- Did you achieve the goals you set out? Summarize these wins.
- What did you learn in the past year?
- What challenged you most?
- How could your manager help you become more successful?
- Are there any new experiences or challenges you want exposure to in the upcoming year?
- Are there training opportunities you want your manager to consider for you?

Deliver your self-evaluation to your manager well before your review meeting. I suggest emailing it so you'll have an official record. Give your boss enough time to react to your self-assessment as they prepare for the review discussion.

Sending it the day before your review is a waste of time.

At the meeting itself, do your part to make your review discussion a genuine dialogue, a real two-way conversation.

Be prepared to hear feedback that may make you uncomfortable. Ask questions to clarify. Take notes and digest. It doesn't matter whether you believe the input. Any feedback you receive from your manager has items you must address to be successful in their eyes. I repeat, *to get ahead with your boss, you need to act on their feedback.*

Don't phone in your review. Seriously. If you know the meeting should be on the schedule by now, follow up and request a date. Many managers mean well, but they might suck at the "people" side of their job. Don't allow their weakness to become a missed opportunity for you.

Finally, make the most of your conversation. All too often, annual reviews become squandered opportunities. This is your career. Take advantage of this opening. It's your chance to get your kick-ass qualities and accomplishments acknowledged and documented.

Here's your chance to get objective feedback on how you can kick ass at the next level. Make the most of it.

Use these tools to ensure the word gets around about how great you are.

Hack #12:

Win at the Promotion Game

You should know by now that you need to look out for yourself.

You cannot count on other people to connect the dots on your behalf.

Embrace the idea.

Feel good about it.

You have control and power over your career path; act that way.

I have asked for every promotion or significant increase in responsibility that came my way.

You will need to, too.

Countless articles will tell you how to ask for a raise or a promotion. While these pieces make for great headlines on the cover of *Cosmopolitan*, they also grossly oversimplify the matter. Sure, it's excellent advice to speak up for yourself and get what you're worth. But I am here to put their advice through a real-world filter.

To work a system, you need to understand how it functions.

To game a system, you need to understand the rules of play.

You wouldn't swoop down in the middle of a board game and change the rules to win—if you tried that in middle of Monopoly, your friends would pitch a fit! The same goes for asking for a raise or a promotion. You need to understand your environment and your company's process before you put forward your case.

Every company has a process by which they manage promotions and raises. Some may be flexible, though many are quite rigid. Some may have a well-documented process, while others may treat this topic more informally.

Your mission is to figure out your company's process.

Find out what you can from employee manuals. Read the materials provided to you by the human resources team. Ask about the formal process in your check-ins with your direct manager. See what you can learn from recently promoted co-workers.

Here are a few strategic elements of information you need to understand the rules of the game.

Success Strategy #1: Figure out the regular cycle and timing of promotion and raise decisions.

Although one-off choices may be possible, they are not likely. Your company has a calendar for making these decisions. Is it annual, semi-annual, quarterly, or monthly? If you can't answer that question, you need to find out.

Even if your case is compelling and your boss is on board, you will not get what you ask for instantly. You've got to time it right with the company's processes. Be smart and

strike at the right time.

Success Strategy #2: Keep a sense of business realities.

Think about it. Employee salaries are an enormous cost to the company. How is the company performing? Consider what you want to ask for through this sharp lens of reality.

If the company is in growth mode, it's an ideal time to put forward your case. Growth mode most likely means the company is hiring. Are they hiring the position you want? Perfect, make this part of your overall presentation. Can you apply formally for that position? Even better. Do it.

The flip side is if the company is having a lousy year. How is their stock performing? Have there been recent significant business losses? If so, your company is probably looking to reduce costs, not raise them. Don't misunderstand me; this doesn't make promotions impossible, but this climate will make it tough. The harsh truth is that the promotion budget for the company will be significantly reduced, or maybe even frozen. If your company isn't in hiring mode, your presentation will need to be rock solid.

Success Strategy #3: Understand how you and your performance will be judged.

Your manager and other leaders will make value judgments on your performance to date. Do you understand the measuring sticks for your performance?

A good place to start is your official job description. Read it

through thoroughly. Have you gained the experiences listed? Have you had the opportunity? If not, these are experiences you should seek out. Ask for them during informal or formal review discussions with your manager. If you see an opportunity to volunteer for, take it. Put yourself out there. Don't wait for anyone else to offer it to you. Ask!

I recommend getting a copy of the job description for the role one level up from yours. Could you take on any of the described duties in your current position? How can you gain experiences that align with the next level? Again, these are conversations you can and should hold with your manager or appropriate team members.

The best way to show that you are competent enough for the next level is to do it. Seriously. As a general rule, prove that you can do everything in your job description, along with roughly half of the job description one level up. This rule may be unreasonable or counter-intuitive, but think about it. If your boss were hiring someone at that next level up from you, would they hire someone who didn't have abilities and a track record of doing the items in the job description? Of course not. So why would they consider you for that level if you haven't proved that you can do at least half of that job description?

As you review written job descriptions, you should also understand that the description is not a simple checklist. Meaning, just because you completed a project once doesn't mean you're good to go. It takes practice to master a task. Practice takes time. Time in the role will be a factor by which others judge your performance. If you have been doing your

job for less than a year, chances are it's too soon to ask for more. Sure, exceptions to every rule exist. But company leaders want to see a track record of sustained performance. A few months is not enough.

To figure out the promotion and raise process, learn everything you can about these points.

Use your formal and informal channels to get at this information.

Information is power, and it will help you put forward the best case possible.

Learn the rules in order to win the game.

Hack #13:

Judge Your Boss's Character

You've been doing loads of self-reflection on your performance.

It's time to take a good, hard look at another person: your boss.

As your direct manager, your boss has direct power over your career path at the company.

How high or low on the pecking order your boss is doesn't matter.

If they don't believe in you, your career at the company will only go so far.

If they are not coaching you, they are not helping you be the best you can.

If they aren't fighting for you, you will not have upward mobility.

The world would be a happier place if every manager were great at her job. If you are lucky enough to have an awesome boss, you already know it. You don't need a questionnaire to tell you so. Great bosses stand out and are instrumental in your professional development.

Sadly, the world is full of mediocre managers and terrible

bosses. Chances are, your manager was an active individual contributor who earned more responsibility, including direct reports. But being great at a craft doesn't automatically translate to being great at managing people.

It is just as easy to recognize if you are working for a terrible boss as a great one.

If they are abusive or just a crappy person, you understand what you need to do. You can't let your career sit in their hands. You need to move on. Find a way to transfer to another team or department or start your job search ASAP! Crappy people won't change. They might apologize for their behavior with empty words or gifts, but they will never change. Break the cycle and move forward.

So, what about most managers, who fall somewhere in between amazing and crappy?

If your boss isn't one you'll fondly remember in your career, this doesn't necessarily mean you should leave. A relationship between a manager and an employee is a relationship between two people. You are 50% of the conversation, so you can do your part to connect better.

What do you love about your boss? What frustrates you about the relationship? Take out a piece of paper, draw a line down the middle, and list your thoughts. Put it on paper; it will help you process the information better than just thinking about it.

Once you have that side-by-side comparison, review it with objective eyes. Perhaps some qualities or attributes you admire in your manager could help improve the weaknesses in

your relationship. Can you gracefully suggest how to improve your interaction? What do you contribute to the items that frustrate you? Could a change in your behavior help ease your frustrations?

Take action where you can. If you can make appropriate suggestions, open a dialogue. This is a two-way street; you may be surprised how much you can improve the situation. If you wait for things to change, they won't. Things will probably get worse if you don't act. You are a vital person in this relationship: take action.

What if your boss is mediocre? They're not inspiring you, but they aren't doing anything to bother you, either. Consider your answers to the following questions, as they are the deal breakers.

The Deal Breakers
1. Is your boss giving you helpful feedback and coaching?

Even if the information doesn't come gracefully, you want to be receiving feedback. If your boss is not giving you insight into how you are performing, they are not investing in you. *It's time to find a new boss.*

2. Is your boss singing your praises?

You will know when your boss is proud of you. People remark on it. You get copied on notes. Your boss's boss knows you, or they don't. If your boss isn't sharing your

successes, this is another big fat clue they have checked out. *It's time to find a new boss.*

3. Is your boss taking credit for your work?

Here is the mother of all deal breakers. If your boss is taking full credit for your work, and not giving you praise or accolades, she cannot be trusted with your career. *It's time to find a new boss.*

There are so many people in this world who settle for crappy relationships.

Don't just hope things will get better. They won't.

Find a way to improve your situation.

Life is too short.

There are other jobs.

There are other managers.

Work to make your relationship with your boss better.

If you worry you are beyond the point of no return, make a move and find a new boss.

You aren't someone to settle for being a backseat driver in any other facet of your life.

Don't settle for less now.

Hack #14:

Apply a Simple Formula to Get What You Want

You're not shy.

You're ready to ask for it.

Whether you are asking for a promotion, a new responsibility, or any significant request or ask—there is a single underlying formula to help you get what you want.

That is a bold statement, I know.

But I can speak from my own experience that the formula works. And anytime I've advised others to follow the method, they have seen successful outcomes.

Let's be clear: "basic" does not mean "easy." It will require you to do your homework and put together a well-articulated plan. You realize by now there are no shortcuts to success, so this should not surprise you one bit.

Before we go into the basic formula for a successful presentation, here are a few pre-requisites you must apply.

Success Strategy #1: Ground your ask in business realities.

It feels personal, but don't make it so.

Chances are your request feels personal—very personal. Even if it's not about your job title, or salary, the cause is important if you care enough to ask for it.

Pause and take a deep breath.

Even if your mission is so personal that you are losing sleep over it, you must treat it as a business issue.

Separate yourself from all the emotions and consider the request from a cool-headed approach grounded in business realities.

Success Strategy #2: Separate fact from opinion.

What do you know to be true, versus what do you think is true?

If you build your case with statements that start with the phrases "I think..." or "I feel..." chances are you are basing your arguments on your opinion and not provable facts.

Your case must be based on facts. Even if your opinion is 100% valid, you must tell your story with facts and not your own theories.

Success Strategy #3: Seek win-win situations.

It can't be just about you. Consider who will hear your ideas. Does your proposal have an upside for your intended audience?

Craft a story that benefits both parties. Approach your presentation from a "we" perspective, as opposed to an "I" perspective.

Success Strategy #4: Be concise and clear.

Less is more when speaking to executive audiences.

From start to finish, your presentation should boil down to less than ten slides and conclude with an explicit request. Slides full of statistics and charts mean nothing if you can't get to the point with clarity and conviction.

If you can't tell the story effectively, you aren't ready. This isn't just about taking up too much time from an executive's calendar, although that's a relevant point. You need to show that you have a clear handle on the information, so get to the point quickly.

To make the presentation formula work, you must apply these guiding principles. They are the foundation of your argument.

There is a simple story arc you should apply any time you ask for anything significant at work. It comprises three elements.

1. The Issue

Describe the business issue you wish to solve. Provide solid facts that provide context and color. Hard facts like statistics or survey data are always a plus. Direct quotes from team members can be useful here.

What facts can help you show the problem is valid?

2. The Impact

Describe the impact the issue is having on the business. What are the ramifications of leaving the problem unsolved? What gains or efficiencies can addressing the problem solve?

Make clear connections to goals established by the company, your team, or your manager.

3. The Solve

Describe your proposal on how you would like to solve the business problem. This is the key to what you are asking.

Give your audience specific recommendations and next steps.

That's it. To make it a winner, you need to bring the story to life with your research and bold ideas. It takes hard work to make it a winning proposal.

I'll describe for you the first time I used this formula.

I was a high-performing project manager at a small advertising agency. I had years of experience under my belt, and I was damn good at my job. Although I was learning new technologies, I was under-challenged and maybe even a little bored.

I found that I was a natural at giving coaching and mentorship to newer employees in my department, and I found it satisfying to do so. These junior employees didn't have a boss in any real way. No one was investing time in helping them grow and, more importantly, determining what better value they could bring to the company. Their boss was just a name on paper.

I saw an opportunity. Why not suggest to my boss that I become their manager? I needed a challenge; they needed a real boss. Easy enough, right?

But would my boss understand the problem that needed to be solved? What if she took my idea as an insult?

Lucky for me, my instincts kicked in. *"I can't go marching in there with this demand. She doesn't even know me that well and doesn't see the problems I see every day. Why would she entrust me with this responsibility?"*

I took a step back. How could I effectively tell the story to make my boss receptive to my idea? This quest for weaving the story together became the basis of the formula I've applied countless times since.

The Issue:

Roles for our junior employees in our department were not clear; these employees were not being managed as a whole and were not consistently being provided with individual mentorship.

The Impact:

This lack of role clarity was causing mistakes in our work product. Lack of management and career guidance was also affecting employee morale. I backed both points with specific examples.

The Solve:

My pitch for how the role of the junior team should focus and reset, how the team should be managed and mentored, and why I was the right person to lead the team.

Was I nervous? Yes! But I did it anyway. I set up time with my boss and walked her through my idea.

Guess what? She was blown away! I had done nothing rev-

olutionary, but the fact that I brought it up to her in the first place was what impressed her.

She didn't expect this thinking from a mid-level employee at all. I built up a business case to describe a company issue, explained why it was important, and offered her a solution that came complete with a person to drive it forward (me).

I went from an employee on the periphery of her consciousness to an up-and-comer to be watched with one thirty-minute conversation.

She didn't say yes to my proposal right away. Although I could see she positively received my ideas, she needed time to digest, deliberate, and likely consult with other leaders in the organization. But within a few weeks, my proposal won approval, and I was on to my new role and responsibilities.

Here's the thing about putting forward your smart ideas in a proactive, deliberate way:

Win or lose, YOU WIN.

Even if your idea gets rejected, you have stood up as a proactive, intelligent, and driven employee. Where's the downside to that? There is none.

But if your ideas connect to the business and making it better, get ready to execute your plan because all signs will point to YES.

· · ·

You have talent, motivation, and the ability to master any career you set your mind to.

You can weather the ups and downs this journey will take you on.

You *will* be a smashing success.

Not just because you know no other way to be.

You are driven to make a difference.

You don't want to live in a world that you can't make a mark on. Neither do I.

I've been employed in various parts of corporate America since I turned 16. That's over thirty years of seeing shit that riles me up.

Women who regularly undersell themselves.

Women who huddle quietly in the back of the meeting room and who don't confidently take a seat at the table.

Women who don't speak up.

Women who do the extra work but don't ask for the title to go with it.

Women who can contribute in a more meaningful way but

wait for permission to do so.

Women who become irrelevant because they don't keep pushing themselves to learn new things.

Women who settle for working for managers who don't look out for them.

Women who are capable of doing more but don't.

Women who let other people take credit for their efforts.

Women who allow themselves to be taken for granted.

Are there cultural norms and system inequities that make things harder on women? Yes.

Are there women who let life happen to them and settle? Yes.

But I don't.

And I'm counting on you to do the same.

But not just for you.

For us.

I am truly inspired by your generation. You have more than the optimism and vitality that comes with youth. You see the beauty in our differences. You believe that we're better together than apart. You have heart. You give me hope.

You and your generation can and will bring our collective cause for gender equality further. Maybe even solve it once and for all.

So I humbly offer you some practical advice and tools to help you hack the system and climb up that corporate ladder quicker than any generation before. I hope these hacks provide you with some shortcuts to success. It took me many years to learn them; many were learned the hard way. Receive them as the gifts they are intended to be, from one Real-World Fem-

inist to another.

Take them.

Try them.

Invent some of your own.

Most of all, share them.

No Real-World Feminist can do it alone.

We need each other to be successful.

We can do this.

We will do this.

With a heart full of love and hope,

The Real-World Feminist

xo